# Rembrandt's Nose

*Of Flesh & Spirit in the
Master's Portraits*

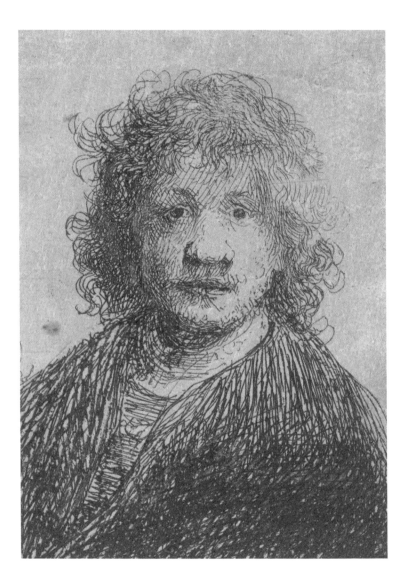

# Rembrandt's Nose

*Of Flesh & Spirit in the*

*Master's Portraits*

by Michael Taylor

d·a·p

Distributed Art Publishers, Inc.

New York

*For Irina and my daughters Viva and Maya*

Rembrandt's Nose: Of Flesh & Spirit in the Master's Portraits by Michael Taylor

Production Manager: Jenna Adams
Design: John Hubbard
Typesetting: Marie Weiler
Separations: iocolor, Seattle
Produced by Marquand Books, Inc., Seattle
www.marquand.com

First Edition
Printed and bound in China
10  9  8  7  6  5  4  3  2  1

Published by:
D.A.P. / Distributed Art Publishers, Inc.
155 Sixth Avenue, 2nd Floor
New York, NY 10013
T 212.627.1999, F 212.627.9484
www.artbook.com

Title page: *Self-Portrait with a Thick Nose*, 1628, [ill. 9].

Page 8: *Self-Portrait*, 1629, [ill. 6].

Library of Congress
Cataloging-in-Publication Data
Taylor, Michael, 1966–
    [Nez de Rembrandt. English.]
    Rembrandt's nose : of flesh & spirit in the master's portraits / by Michael Taylor.
        p.  cm.
        Includes bibliographical references.
        ISBN-10: 1-933045-44-2 (hardcover)
        ISBN-13: 978-1-933045-44-3
        1. Rembrandt Harmenszoon van Rijn, 1606–1669—Criticism and interpretation.
    2. Portraits, Dutch—17th century. 3. Nose in art. I. Rembrandt Harmenszoon van Rijn, 1606–1669. II. Title.
    N6953.R4.T3913 2007
    759.9492—dc22                    2006036412

# Contents

# Acknowledgments

Writing an essay on Rembrandt and the way he depicted noses – his own and that of his sitters – seemed so obvious to me that I was surprised no one had done it before. It also looked like a particularly hazardous undertaking for someone like myself who is not an expert on Dutch seventeenth-century art. I launched into it at the prompting of this book's original publisher, Adam Biro, who liked the ring of the French title *Le Nez de Rembrandt*, overcame my misgivings, and took the risk of commissioning it in English and having it translated. His advice and encouragement, as well as those of Irina Zarb; Richard Crevier, my French translator; Sharon Gallagher at D.A.P.; and Jaap van der Veen at the Rembrandt House in Amsterdam were invaluable. Simon Schama was the giant on whose shoulders I stood. His book *Rembrandt's Eyes* helped me to see what I would otherwise surely have been blind to. I am deeply grateful to them all.

—Michael Taylor

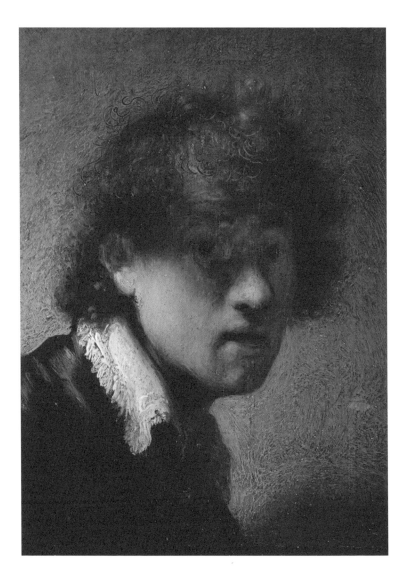

In early accounts of Rembrandt, the thickness of his pigment consistently draws comment: paint an inch thick; a portrait painted so that the canvas could be lifted by the sitter's nose; jewels and pearls which seem to have been done in relief. Houbraken makes a story of it: he tells how "in order to maximize the effect of a single pearl, Rembrandt painted out the figure of Cleopatra."

<div align="right">
Svetlana Alpers,<br>
<em>Rembrandt's Enterprise</em>, 1988[1]
</div>

*Le nez de Cléopatre: s'il eût été plus court*, *toute la face de la terre aurait changé*. (If Cleopatra's nose had been shorter the whole face of the Earth would have been different.)

<div align="right">
Pascal, <em>Pensées</em>, 1670
</div>

Please restrain yourself! This is my painting.
I shall be paying you £30,000 for this unauthenticated copy of a French Rembrandt . . . . There, that's a splendid nose!
 . . . . Keep that and you can burn the rest.

<div align="right">
Sir Guy Grand to a director at<br>
Sotheby's as he cuts out the nose on<br>
a "School of Rembrandt" canvas he<br>
has just acquired in Joseph McGrath's<br>
film <em>The Magic Christian</em>, 1969
</div>

---

1. Gary Schwartz gives a somewhat different interpretation of Houbraken's statement: "In order to bring out the strength of a single pearl, [Rembrandt would have] covered a beautiful Cleopatra completely under *taan* . . . a transparent, yellow-brown shellac that darkened with age . . ." (*Rembrandt: His Life, His Paintings*, London: Penguin, 1991, pp. 353–54).

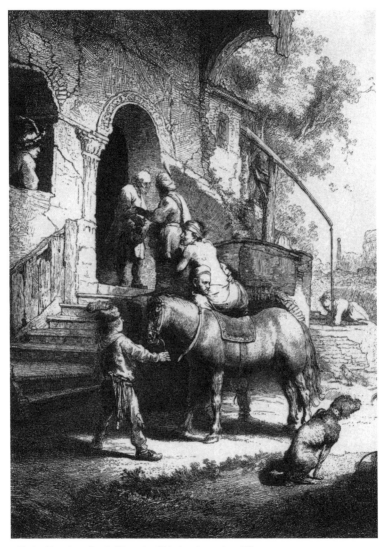

1. *The Good Samaritan*, 1633. Etching, 10⅛ × 8⅜ inches. Amsterdam, Rijksmuseum.

# 1

# Group Portrait of a Man and a Dog, Both Looking out of Place

Dogs make a number of appearances in the work of the miller van Rijn's son Rembrandt, though relatively few compared to how often they appear in most seventeenth-century Dutch art. They're a motley lot, these dogs he sketched, etched, or painted – scruffy mutts intruding rudely, as often as not, on the high drama of biblical scenes, like the hound shitting in the foreground of the *The Good Samaritan* [ill. 1]. The inverted pyramid of his straining, malodorous dogginess snags the viewer's eye, as it catches that of the servant helping the injured traveler off the horse. It drags it down from the old innkeeper standing in the doorway of his establishment, plainly fallen on evil times, at the top of the composition's central grouping of figures. Why has the artist put it there, you wonder, and why has he lavished so much loving attention on the details of its fur, the soft curls on its ears and snout?

To fill an awkward hole in the composition? As a throwaway item of scatological humor? A sample of a cocksure young artist's insolence?

Defecating dogs are almost a cliché in Dutch art. They were used to illustrate the sense of smell in allegories of the five senses, popular with collectors who wanted pictures that told a story or made an obvious point about the down-to-earth world they lived in and from which they escaped on Sundays when they sat in church, singing hymns. They were a regular feature in scenes of peasant revelry, along with tipsy couples making love and little boys urinating. They were part of the lore of rustic ribaldry that the citizens of the Dutch towns delighted in just as city dwellers cling to their distant country roots, and no doubt too because, between occurrences of the plague and the fulminations of preachers and other guardians of public morality, they needed to laugh and share the laughter of their guests.

But Rembrandt had a different purpose. The parable of the Good Samaritan is, after all, a fable of indifference and compassion. A traveler on the road from Jerusalem to Jericho is attacked by thieves, robbed, and left half-dead in the dust. Of the three men who ride past him in succession later that day, two of them, one a priest and the other a Levite, cross to the other side of the road and keep walking. Only the third, a foreigner from Samaria, is moved to come to his aid. He bathes the traveler's wounds in oil and wine, hoists him onto his horse, brings him to an inn, and, before continuing his journey the next day, pays the innkeeper two *denarii*, saying, "Take care of him; and whatever more you spend, I will repay you when I come back."[2]

---

2. Luke 10:35.

Rembrandt's etching conflates the arrival of the Samaritan's party at the inn and the paying of the innkeeper. Its Constructivist composition of interlocking triangles is a subtle balance of contrasting values and textures: gritty sunlight and velvety shadows, crumbling masonry and an array of feathery notations seemingly impossible to produce with an etcher's burin – the grasses and the bundle of reeds in the right foreground, the wispy tail of the horse, the frothy plume on the groom's hat, the feather in the cap of the idler at the window, the aigrette in the Samaritan's turban, the faint summer foliage behind the inn, the dry leaves spiraling toward the maidservant drawing water from the well, and the tuft of hair escaping from her bonnet. Enmeshed in this web of painterly details, still more contrasts drive home the lesson of this thoroughly Dutch and domestic-looking New Testament scene. The artist has woven together a dreamy contemplativeness and instances of tremendous effort and tension, notably in the grouping of the injured traveler being lifted off the small yet statuesque horse that appears to have dozed off in its pool of shrunken, noontide shadows. Not to mention the dog squatting by the horse's hindquarters, voiding its bowels, straining to spend itself in a weirdly oblique rhyme of the Samaritan's lordly gesture of depositing coins in the innkeeper's paw.

Before a backdrop representing a derelict country inn with an ancient, vaguely exotic flavor, a badly injured man is being helped to the ground. A cluster of figures is posed around the steps leading to the inn's front door, each absorbed in his or her own occupation or preoccupation. What defines them as individuals and at the same time draws them together is the abbreviation, the shorthand of their

features, chiefly their eyes and nose. The young groom holding the horse is summed up by his bodyguard's stance, the sash and dagger at his waist, the half-moon of his beardless face with the single dot of his right eye and the bright button of his pug nose lifted to the rescued traveler, whose own features contract in a wince of pain. The servant helping him down, on the other hand, hardly seems to notice the weight of the wounded traveler's body. Only the pressure of his fingers squeezing the folds of the injured man's robe shows the effort involved. He has caught sight of the dog and is staring at it, frowning and wrinkling his broad nose. He's the only figure in the etching to notice it. At the entrance to the inn, the innkeeper's eyes peer out from either side of his withered, bony nose in suspicion or puzzlement at the Samaritan, whose facelessness, like that of Christ in the *Supper at Emmaus* in the Musée Jacquemart-André in Paris, is the most tantalizing detail in the image. That glimpse of the cheek behind his left shoulder makes us want to step into the picture to see who this good man is. The youth leaning on the sill of the window on the left could tell us, as he appears to be gazing straight at him, but his profile is inscrutable; or if it expresses anything at all, it is the boredom of a young man—a soldier—a traveler?—who has seen vastly more exciting sights than a random act of kindness. He has knocked around and has a broken nose to show it.

The main group, then, is enclosed within an acute triangle, the angles of which are the jaded spectator at the window, the girl at the well, and the dog—three uninvolved figures. The first gazes idly at the scene because, at last, something is happening in a place where nothing much ever happens. The second doesn't even glance up from

her chore of bringing up a bucket of water—for the horse?—from the well's darkness. And the third, the most prominent of God's creatures in this composition, placed squarely (if somewhat precariously) in the foreground, and extraordinarily large compared to the other figures, is simply going about its canine business. So deeply wrapped is the dog in its own physical nature that, in contrast, the stolid, infinitely patient horse, the lightly sketched chickens, the haze of leaves in the background, even the crumbling romantic stucco and stonework of the inn, look a trifle ghostly. The dog alone is one-hundred-percent real, as real as the springy softness of the fur on its muzzle lifted into the brightness of an event passing its understanding.[3]

This is not the first time we meet this dog, or one like him, in Rembrandt's work. In 1631, the year the twenty-five-year-old artist left his native Leiden and moved to Amsterdam to take up the position of chief artist in the workshop of the dealer and art impresario Hendrick van Uylenburgh, he painted a portrait of himself posing as an Oriental pasha: *The Artist in Oriental Costume, with Poodle* [ill. 2]. This is the only self-portrait in which he depicts himself full-length, with the possible exception of *The Artist in His Studio* (painted a couple of years earlier), which hardly qualifies as a self-portrait (it's more like

3. There is another version of *The Good Samaritan*, in oils, at the Wallace Collection in London, done in pale ochre, honey, and light-green tones by one of Rembrandt's students (perhaps Govert Flinck, his successor as master at the Uylenburgh academy). It is exactly the same size as the etching, but the composition is reversed, suggesting that it was copied from a counterproof; that is to say, a print of a still-damp print. (Being reversed twice, the image corresponds exactly to the design on the original copper plate.) However, the details in the foreground have been deleted—in particular the defecating dog—presumably in an effort to make the image appealing to a more refined class of buyer.

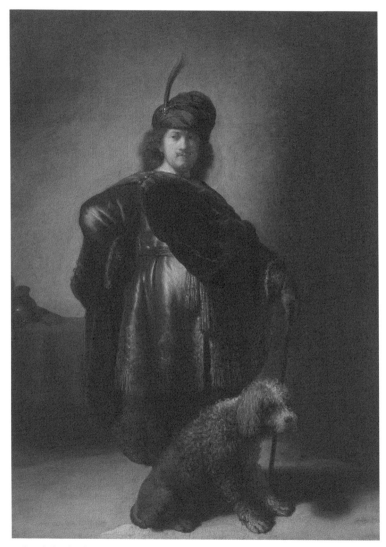

2. *The Artist in Oriental Costume, with Poodle*, 1631. Oil on wood, 26¼ × 20½ inches.
Paris, Petit Palais, Musée des Beaux-Arts de la Ville de Paris.

a caricature of the artist as a gingerbread man). An odd, swaggering, theatrical composition, it depicts the painter standing against a bare wall, sporting a turban garnished with an aigrette, much like the one worn by the Good Samaritan, and garbed in a shimmering, burnt-gold satin robe, an imperial purple velvet toga flung negligently over his right shoulder – absurdly grand attire for a youth of Rembrandt's class. His attitude is resolute, almost pugnacious, in the martial hand-on-hip posture favored by princes and triumphant generals.

The panel may have been painted as a self-advertisement shortly before Rembrandt left his parents' home, though more likely it was produced after his arrival in Amsterdam as an assertion of his newly acquired status as a master painter in the Dutch metropolis – a visual equivalent of Rastignac's oath on first arriving in Paris, that he would lay the city at his feet. At all events, it was clearly made to impress, and of course it does impress: the handling of textures is stunning. One has an almost physical sensation of the sheen of the robe swelling over the sitter's prosperous paunch; one can almost feel the touch of the gossamer tassels of the sash, the nubbly brocade on the hem. Yet even a child would spot it for what it is: a piece of grotesque posturing. In fact, the artist himself seems aware of this. There's something about the way his gaze slides away from the viewer's which suggests that the painting isn't intended to be a simple fiction. It's a demonstration of painterly skill – not the artist as a young pasha, but the artist as himself playing the pasha. Give him another costume and he'll portray himself (or whoever he's commissioned to portray) in another role. He's versatile. He can render the feel of materials and textures like the best masters. Like Titian, like Rubens.

At some point after the painting was completed, someone – possibly a pupil, more likely Rembrandt himself, but in any case a virtuoso with the brush – added the dog in the foreground, placing it in roughly the same spot within the composition as the dog in *The Good Samaritan* (the two works are roughly contemporary). Art historians speculate that the dog was inserted in the composition because the artist was unsatisfied with the handling of the sitter's feet. Perhaps so; the artist's right foot, or what we see of it, does indeed look awkward. But if the dog wasn't there from the start, surely in a sense it *had* to be there: it gives the picture its flavor and wit, its enigmatic depth of feeling. For one thing, it's the wrong breed. A true pasha would have had himself portrayed with his favorite Afghan, or some such hound. Instead, we have a barbet, an early species of poodle, a Dutch waterfowl-hunting gentleman's dog. Then too, the creature looks a little cowed, unhappy at being obliged to sit. Unlike its scruffier brother in *The Good Samaritan*, who is simply oblivious of his surroundings, this dog clearly wants to be elsewhere. It looks out with vague reproach toward the painter behind his easel. Rubens would have chosen a dog with a silkier coat; he would have seen that it was carefully groomed; he would have lavished effects on the truffle of its nose, the liquid devotion in the eyes. He would have made it match the sitter's aristocratic demeanor. However, Rembrandt paints his dog not to enhance the social standing of the human subject, or to express a kind of lofty, affectionate simplicity of soul, but, on the contrary, to bring him down a peg or two, to prevent him from taking himself too seriously.

For in this bizarre "group portrait" of a man and a dog, both figures look out of place. The "master" gazes off to the left, the dog

stares to the right; both appear to have clumsy feet, both have wiry, maroon hair—with coppery highlights here, faded chestnut tones there—manifestly resistant to any hairbrush. They're a pair, this man and "his" dog, almost Laurel and Hardy (for we are surely on the verge of comedy here). And just as the dog's face is divided by a streak of soft, whitish fur sprouting on its muzzle and thinning out toward the crown of its head in a canine mask that leaves the faint spark of its eyes glimmering in deep shadow, the man's features are dramatically patterned in a play of dark and light areas distributed around the strong, irregular ridge of his nose.

In fact, it's the well-shaped, resolute nose that seems to model the man's face. The lips are pursed to a thin slit that belies the sociability suggested by the upward flick of the mustache; the jaw is thrust forward, as if determined not to make conversation; the eyes are small and parsimonious and seem loath to communicate with the spectator. The nose alone is eloquent. With its finely shaped nostrils, the tiny dimple on its tip mocking the more pronounced dimple on the chin, the merest hint of a muscular, mobile, generous, and sensitive nature, it proclaims the man who wears it.

Not all of Rembrandt's early paintings are signed, but this one is: *Rembrandt f* [ecit]. Rembrandt—simply his forename, like Raphael, Titian, Michelangelo, or Leonardo—made it.

# 2

## "Without a Nose, a Man Is No Longer a Man."

"Without a nose, a man is no longer a man," laments Kovalyov, the hapless hero of Gogol's story "The Nose," voicing what any psychoanalyst would term an acute castration complex. Whatever psychological interpretation one gives to noses in Rembrandt's work, one cannot fail to be struck by the fact that, like the Caucasian Collegiate Assessor's truant appendage, they possess a will of their own. They have their own inclinations and seem to obey their own promptings rather than the laws of objective resemblance. They are long and slender, flat and squat, smooth or wrinkled, bony or fleshy, dainty or gross, pitted, scarred, inflamed, unblemished—less, one feels, for reasons of fidelity to the sitter than for reasons dictated by the artist. What is more, their role in the composition is never (or almost never) merely incidental or random: one seldom gets the impression that the artist has

labored over a nose simply because the nose was there and because a face without a nose is an anomaly. (Rembrandt was not averse to depicting the anomalous, but although representations of physical ailments or infirmities – especially blindness – are frequent in his work, there isn't a single instance of, say, a nose eaten by leprosy, a not-unheard-of sight in seventeenth-century Holland.)[4] In many of his drawings and some of his etchings he indicates a nose with a vertical tick or, more rarely, a pair of dots for the nostrils, but there are no summary noses in his paintings, and especially not in the "free" oils of his late manner. Rembrandt lavished as much care on layering pigment to build up a nose as on capturing the play of reflections and shadows in an eye. He rendered the complexion of a nose with the same fastidiousness he brought to paraphrasing the sheen of velvet or fur.

In his portraits and self-portraits, he angles the sitter's face in such a way that the ridge of the nose nearly always forms the line of demarcation between brightly illuminated and shadowy areas. A Rembrandt face is a face partially eclipsed; and the nose, bright and obvious, thrusting into the riddle of halftones, serves to focus the viewer's attention upon, and to dramatize, the division between a flood of light – an overwhelming clarity – and a brooding duskiness. If the sitter is the lead actor of a performance (which is what a portrait is, in essence), then the nose is his understudy on the stage of the face.

---

4. There actually is one leprous figure in Rembrandt's work: the old man in Oriental garb in a painting of 1639 or thereabouts traditionally (and perhaps erroneously) identified as *The King Uzziah Stricken with Leprosy*. The face exhibits gray patches, which suggest leprosy, but the nose is intact, though swollen and pustular.

The nose stands in the center, the focal point of our gaze, if not the exact center, and demands that we notice it. It's a peacockish actor: too obvious, too egotistical, too histrionic. It upstages the rest of the face and would make us forget that its posturing is mere vanity and vacuity compared to the eloquence of the eyes and lips.

Rembrandt tried on faces—and noses—like a child making grimaces in a mirror. Of the eighty-odd self-portraits now accepted by Rembrandt scholars (some forty oils, thirty-one etchings, and a handful of drawings), no two are alike. While all are recognizable as portrayals of the same man at different stages of his life and in different roles, circumstances, and moods, they display such an extraordinary variety of expressions, and the features are molded in such a diversity of shapes, that looking at them as a body is like leafing through the scrapbook of an actor blessed with a particularly rubbery face. Here is the artist as a soldier; here he's a gay blade, a beggar, a burgher, St. Paul, Democritus; here he is laughing or putting on a frown; here he looks terrified; here, inexpressibly sad.

Why did he do it? Was he a Narcissus? An exhibitionist? A perpetual adolescent, self-engrossed, obsessed with his looks, vain about his virility, or wounded by the fact that his mug was decidedly not an aristocratic face? Did he crave seeing his reflection staring back at him as a confirmation of his own existence? Was there a loneliness in him that made him populate his crowded universe—all his life, except for his largely solitary final year, he occupied dwellings thronged with women, children, housemaids, assistants, students, models, patrons, and visiting art lovers—with clones of himself? Was he like Montaigne a couple of generations earlier, a man who studied himself as a way of

studying all humanity? (*Nosce te ipsum*, "Know thyself," seems to be the subtext of his famous *Anatomy Lesson of Dr. Tulp* [ill. 28].)

No doubt he was all of these, to an extent, though first and foremost he was an artist unusually aware of the theatrical aspect of representing figures in space, even when they stand alone, isolated, like Hamlet soliloquizing "To be or not to be?" on the edge of the proscenium, probing his conscience in the hope of provoking it to come up with some kind of answer. Svetlana Alpers and other scholars have shown that Rembrandt's teaching method actually involved a measure of acting.[5] Students working on a history painting were made to enact the scene they were about to depict. Before they even took pen to paper or brush to canvas, their master criticized their gestures, their grouping on the studio floor, their diction, as if it were impossible for him to imagine painting as anything other than a dramatic performance.

The practice of having students make faces and gestures, or of the artist making them himself in front of a mirror and then sketching or painting them, was related to the well-established Dutch genre of the *tronie* – the "physiognomy" or "phiz," as a later age would call it.[6] Rembrandt's contemporaries do not seem to have found anything particularly remarkable about his habit of depicting himself over

5.  See Svetlana Alpers, *Rembrandt's Enterprise: The Studio and the Market*, Chicago and London: The University of Chicago Press, 1988, Ch. 2, "The Theatrical Model," especially pp. 41–47 of the 1990 paperback edition.

6.  A *tronie*, though drawn after life, was not considered a portrait of a particular individual but a study of character and expression and an opportunity for the artist to show his skill at rendering facial types, lighting, and theatrical clothing. The market for *tronies* in seventeenth-century Holland was large and low-priced: a Vermeer *tronie*, possibly the *Girl in a Red Hat*, sold for 10 guilders at the sale of the sculptor John Larson's collection in 1664.

and over again, trying on this or that expression. (They commented about other things, like his bearishness and his unflattering depiction of flabby female thighs and breasts.)[7] In any event, no artist before Picasso has given his own features such a central place in his art or rendered them so variously and freely; no painter except Picasso ever portrayed himself in such a staggering variety of roles. To be sure, Rembrandt respects the geography and topography of the face and is always plausible, if not true to life, but he takes the liberty of modeling his own features, and those of his sitters, with highlights and shadows, the atmospherics of emotion and mood; and he uses them to a degree never before attained in art. From his own physiognomy he produced a range of expressions and types any actor would envy.

In 1629 or thereabouts, shortly before Rembrandt and his (at the time) friend Jan Lievens left Leiden to seek their fortunes in the wider world, Lievens did a portrait of him [ill. 3] attired in the same white scarf over the same piece of armor – a gorget – that Rembrandt wears in one of his early self-portraits, painted around the same time. Two versions of the same sitter, aged twenty-three, but how different they are!

---

7. Thus the poet and playwright (and translator of Horace's *Ars Poetica*) Andries Pels charged in his verse treatise *The Use and Abuse of the Theater* (1681) that Rembrandt was the "first heretic of the Art of Painting" because of his disregard of the classical rules of that art, instancing:

> "When he a naked woman, as it sometimes happened,
> Would paint, [he] would chose no Greek Venus as a model,
> But sooner a washerwoman, or a peat trader from a barn
>                  . . . . Sagging breasts,
> Wrenched hands, even the sausage-like pinch
> Of the stays on the stomach, or the garter on the leg,
> It must all be followed, or nature would not be satisfied."

(The translation, which I have adapted slightly, is given in Alpers, op. cit., pp. 137–38.)

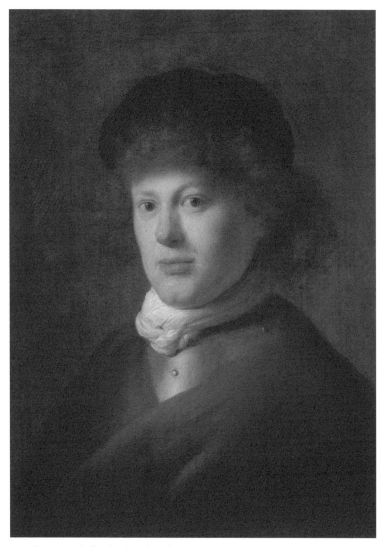

3. Jan Lievens, *Portrait of Rembrandt*, c. 1629. Oil on wood, 22½ × 17⅜ inches. Amsterdam, Rijksmuseum.

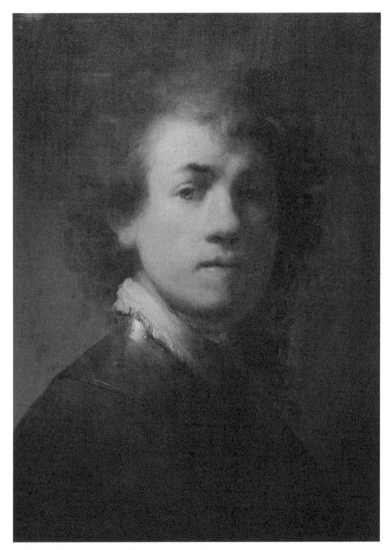

4. *Self-Portrait in a Gorget*, c. 1629. Oil on wood, 15 × 12⅛ inches.
Nuremberg, Germanisches Nationalmuseum.

Lievens concentrates on the lower face, the dimpled chin,[8] the massive jaw, and sensuous mouth, which looks as if it is about to deliver a clever retort. Above the wide upper lip the nose is well-formed, high and rather narrow, the rounded tip looking as if it had just been fashioned by a deft pressure of fingers; the nostrils are small and tight. The eyes are alert, ready to be amused or surprised; the hair, crowned by a soft cap, is reckless and untamed. A good companion, one thinks, picturing the two young artists making a night of it in some back-street tavern well-removed from the watchdogs of Calvinist morality.[9]

Now turn to the version by Rembrandt [ill. 4]. The center of gravity, the weight of the face, has shifted upward to the nose, which juts almost architecturally against the shadowy dark quarter of the moon-like visage. It is only after one's gaze takes it in, with its tip mere millimeters below the picture plane and the soft highlights on the ridge trailing upward into the slight depression between the eyebrows where a thoughtful frown is gathering—only then does one begin to

---

8.  In a self-portrait painted somewhat later, Lievens portrayed himself with an even more emphatic dimple. The thrust of his nose echoes the assertive jut of his chin and brings to mind the profile of the young idler in the window in *The Good Samaritan.*

9.  There are at least two other notable portraits in oils of Rembrandt. One is a painting by his student Govert Flinck in the Rijksmuseum in Amsterdam. Done in 1636, it shows the artist, somewhat improbably, as a thick-faced, ear-ringed young gentleman crowned with leaves and posing as a shepherd. His nose is large, well shaped, and bears little resemblance to the snoot Rembrandt battled with.

The other is a small, unsigned panel in Leipzig painted around 1650. It has been attributed variously to Rembrandt himself, Christian Wilhelm Ernst Dietrich, and Carel Fabritius. Done in Rembrandt's "broad" style, in a palette that could be that of a Nabi artist, it depicts the artist as one imagines he appeared in his studio: blunt, rumpled, and extraordinarily focused. His dark eyes bore into the viewer (though the flesh around his right eye is curiously swollen as if he had recently suffered a blow). His nose is short, thick, rather squashed, and sinks almost bridgeless into the shadow cast by the sitter's flat black velvet cap.

notice the other details of this stunning painting: the reflective eyes, the wisps of hair against the temple and forehead, the humid lips, the five o'clock shadow on the well-proportioned chin, the bright tones on the scarf and gleaming gorget. This is one of Rembrandt's least theatrical, most intimate self-portrayals; it's as much a depiction of the state of being absorbed in thought as it is a straightforward description of flesh. The eyes concentrate the sitter's reflective mood; the nose proclaims his physical reality.

Between 1625, the date of the artist's earliest surviving work[10] (one can only guess at the number of youthful paintings and drawings that were lost or destroyed), and the early 1630s, Rembrandt did history paintings and biblical subjects much in the manner of his teacher Pieter Lastman. He also painted, etched, and sketched dozens of *tronies*, many of them self-portraits, and many of them studies of beggars, vagabonds, cripples, old men and women – including his own father and mother.

It's an odd beginning for an ambitious artist in his twenties. There isn't a girl in the lot. You would have thought Rembrandt was living in a land of outcasts and ancients, not at home with a clutch of brothers and sisters and, surely, a young maidservant or two. Ripeness, the firm lines of a face or body not yet marked by cares, and easy, graceful movements seem not to have caught his eye at this point. (They would later, but he would view them as a middle-aged man who knows how

---

10. *The Stoning of St. Stephen* at the Musée des Beaux-Arts in Lyon, which includes no fewer than three self-portrayals. Rembrandt has given his characteristic ruddy mane, slightly bulbous nose, and mobile mouth to the victim, the executioner, and the ugliest figure in this tableau of primitive violence: the grimacing spectator immediately behind the martyred saint.

perishable they are.) Even at this early stage in his career, he seems to have felt that it was his task as an artist to depict decline and the indignities and impairments that are visited on all living flesh as it ages. No doubt this was less a conscious choice – and was certainly not dictated by any desire to please or any thought that it would make his work attractive to buyers – than a profound impulse of his nature. Even when looking at his earliest work one gets the impression that he could not bring himself to believe in promises of a fullness to come – except the fullness of his own monstrous talent. It's as if he knew in his bones that the blandishments of youth are simply soft soap. What could it have been gave him this knowledge so early in life? The fire-and-brimstone thundering of Leiden's militant Calvinist preachers, the ravages of the plague (which swept through the Lowlands in 1624, Rembrandt's eighteenth year, as it would repeatedly in 1635, the mid-1650s, and the early and late 1660s), the scars of war, the gallows that stood on the town wall around the corner from his home, or the dour pessimism that scowled from the features of his parents, especially his mother, as he portrayed them?

Under the artist's brush and etching needle even the round-cheeked youthfulness that Lievens captures so appealingly in his portrait of Rembrandt becomes a battlefield. Seeing him decked out in high fashion in the Boston *Self-Portrait* of 1629 [ill. 5], garbed in a purplish-gray plumed and jeweled cap and taupe velvet cape edged with a fillet of gold brocade (recalling the gold chain granted to court artists like Rubens or Van Dyke as a royal privilege), you would expect him to look the part of a young dandy basking in princely favor. Instead, he looks shaken. Elongated into a semblance of aristocratic

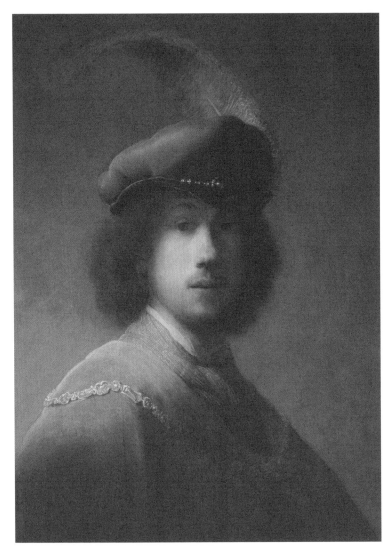

5. *Self-Portrait with a Plumed Hat*, 1629. Oil on wood, 35¼ × 29 inches.
Boston, Isabella Stewart Gardner Museum.

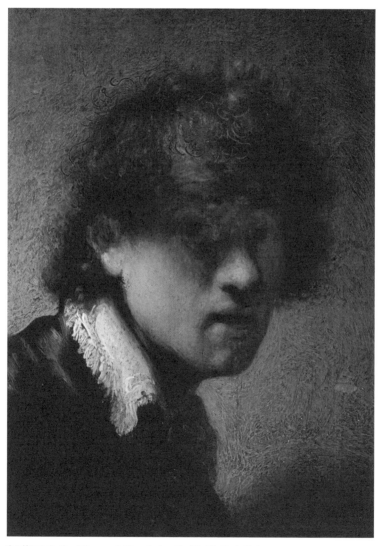

6. *Self-Portrait*, 1629. Oil on wood, 6⅛ × 5 inches. Munich, Alte Pinakothek.

refinement and emphasized by a trim little mustache, his countenance is pinched. His cheeks have lost their plumpness; his complexion is wan, as though he were recovering from a bout of illness. His eyes are small, tired, virtually extinct. The actor has landed a starring role and suddenly he doesn't feel up to performing it. It's not that he has lost confidence in himself; it's that he has suddenly just become aware of the hollowness of the part.

A few months later, perhaps, here he is again, in a small portrait in Munich, this time in the guise of a melancholic genius [ill. 6]. There's something almost Gothic now – the Romantic version of Gothic – about the protean artist-actor. One pictures him skulking on the battlements of the castle of Chillon in a storm, a hectic blast of wind blowing his negligent coiffure over his brow in a parody of a knight's raised visor. The uncertain gleam of pale light on his cheek, the edge of his lips, and the orb of his rounded nose – a pale moon suspended before the stormy moon of his face – appears to be cast by an unsteady lantern, and it reveals a darkness more unfathomable than the murk it lights up. The eyes, nostrils, and parted lips – those gateways to the obscurity within the artist's soul – are caught, in that flickering instant, in a welter of hatched, dabbed, slashed, scraped, and scratched brushstrokes which anticipate the tempestuous surfaces of Rembrandt's final years. He's painted a storm here, in more senses than one.

So powerful is this work, and such power escapes from the infinitesimal reflections of light in the all-but-obscured eyes, that one hesitates to call it a *tronie*. Rembrandt's self-portraits in oils – even this one, which has the look of having been dashed off between other, more careful paintings – are never mere studies of expressions. They are

not preparations for a further level of art. They do not hint of anything to come. They simply proclaim what the artist has wrought. *Rembrandt fecit.*

# 3

# A Nose Like the Latex Stock of a
# Hollywood Makeup Artist

With a few notable exceptions, the forty or so portraits that Rembrandt etched in the first decade of his career—a little over half of them self-portraits—are like keyboard exercises designed to extend and deepen his repertoire of facial expressions as well as his expressive range. Some of them are simple sketches dashed off with a few rapid strokes, others are experiments, still others are bursts of exuberance at mastering a difficult and, for Rembrandt in his last Leiden years, newly discovered medium. Looking at them, one is struck, on the one hand, by the artist's increasing virtuosity at rendering the tactile sensations of hair—the way it nestles in shadows or seems to come alive where light shines on it (his arabesques bring to mind Matisse). On the other hand, one is impressed by the freedom and variety of his handling of physical traits and expressions, particularly those of his

own face: the brow gouged horizontally with worry wrinkles or puckered vertically in a frown; the eyes narrowed to impenetrable slits, peeping like mice from shadows or between baggy lids, open wide in horror, gazing inward in speculation or outward in a cool questioning of the viewer or the world; tough eyes; tender eyes; dead eyes; eyes crackling with wit; eyes that mock and eyes that mourn. They could be the eyes of anyone or everyone, just as the mouth, thin-lipped and tight in one print, fleshy and brooding in another, pouting in a third, sardonic in a fourth, heart-stirringly childlike and vulnerable in a fifth, is not so much Rembrandt's as Everyman's.

And the nose? It's so rubbery, so malleable it could fit anyone's face. A general purpose nose, like the latex stock a Hollywood makeup artist fashions into a monster's snout or a Madonna's virginal nostrils. Of course, it's not just an expression or effect the artist is playing with here; to be sure, the wrinkled nose of the snarling *Self-Portrait, Open-Mouthed* [ill. 10] and the repelled face in the *Octagonal Self-Portrait* [ill. 12] are charged with powerful emotions. It's a matter of delineation, involving the problem of how to represent the nose in a medium where line is everything, and textures, colors, and volumes have to be threaded, so to speak, through the eye of the etching needle.

The problem is compounded by the difficulty of showing the nose frontally or only very slightly to one side, as it must be in a self-portrait executed from the artist's reflection in a mirror. Compare, for example, the early etched self-portraits to the numerous prints of tramps that Rembrandt did in the same period, presumably after life though clearly inspired by the etchings of beggars that the Lorraine artist Jacques Callot published in 1622. In a large number of them

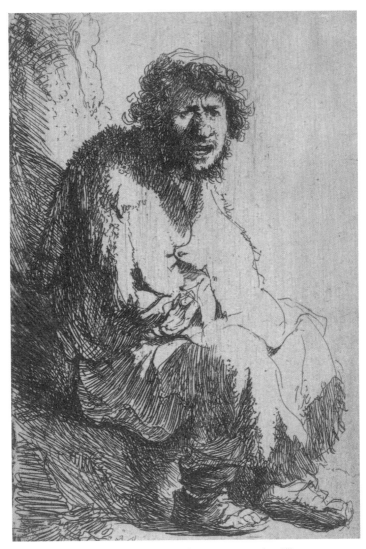

7. *Self-Portrait as a Beggar Seated on a Bank*, 1630. Etching (B. 174). Amsterdam, Rijksmuseum.

a ragged, often crippled, figure is depicted in full or three-quarter profile. (One notable exception is the *Self-Portrait as a Beggar Seated on a Bank* [ill. 7], which presents a hirsute, simple-minded youth slouching on a bank with his mouth agape, growling some cant or obscenity – clearly a genre "type" but, in a fascinating psychological twist, Rembrandt has given him his own facial traits.)

These studies of the unlucky, unloved flotsam of war veterans, orphans, and landless peasants that subsisted on tight-fisted Calvinist charity are summed up by their droop-shouldered stance and battered features; that is to say, essentially by the lines that define their silhouettes. Many of them seem to turn away from the viewer, as if wanting to avert their faces, and in doing so they give us a glimpse of a stunted, broken nose like a badge of their condition. With a couple of flicks of the etcher's needle, Rembrandt outlines the essential character of a physiognomy against a bleak or blank background. He comes close to the snap judgments of caricature and wit for wit's sake in these profiles, yet always retreats into a flurry of hatchings around the eyes or along the jaws, catching at once the hard edge and the shadowiness of his models' despised existence. (One does not pause to consider whether these figures are composites of tramps seen in the street or whether they are "portraits" of individuals who, for the price of a draught of beer, actually sat for the artist. It hardly matters which, for all Rembrandt figures carry the stamp of a unique existence revealed in the act of being depicted. They look as if they were drawn straight from life even when they were composed in the studio.) Rendered around the same time as his early self-portraits as a smart young gentleman or grandee, these outcasts speak of a

fascination with marginality and decrepitude as strong as the pull of lordliness—like Falstaff and Prince Hal vying for attention in the same mind.

Drawing a nose in profile is one thing: a matter of line and outline. Rendering it full-face is another. Its shape and volume are more elusive and indefinable when viewed frontally; it has less character, more substance. No ready solution suggests itself to the problem of how to represent it, other than reducing it to its nostrils and the shorthand of two black dots, inevitably suggesting (whether in petroglyphs, graffiti, or children's drawings) not the fullness of life breathing, but the skull beneath the skin. Of all the facial features, the nose is the most difficult to render visually, and more so graphically. To complicate matters further, unlike eyes and mouths, noses are always open to the world and its smells, and their range of responses is limited to a very narrow play of muscles. They can do little more than wrinkle, stretch fractionally, lean a few millimeters to one side or another, flare their nostrils, or draw them tight in a movement of revulsion so ineffective it requires the aid of pinching fingers to shut out a stench. A nose can't pick or choose what it will admit (although some portraits of highborn sitters seek to convince us otherwise): whatever comes to it, it takes in—the odor of roses or the smell of shit. It houses the most passive of our senses and is shaped by what is dealt to it. Whether a nose is wasted by sickness, garnished with warts or pustules, purpled by intemperance, smashed by a fist, scarred by a blade, swollen by a bee sting or puffy sinus, or is "strong" or "weak," "sad" or "stern," "patrician" or "plebian," its possessor can no more help its appearance than he can control a sneeze.

Except, of course, when delineating his own likeness. Then he is both god and craftsman. He is free to fashion his nose as he sees it, as he would like it, or perhaps as he fears it, and at the same time he has to contend with the problem of getting it to stand out on flat paper or canvas. This is easy when the nose is viewed in profile, but when it is considered frontally, as it must be when the artist is representing himself from life (from his reflection in a mirror) and mere lines have to be made to render the textures and tones of that indefinable protrusion viewed straight on, delineating it becomes something of a contradiction in terms. How can you outline a thing that has no distinct shape except when viewed from the side?

The solution Rembrandt opts for in a sketch no larger than a visiting card and etched in 1628 [ill. 8] – seemingly his first likeness of himself in this medium – clearly doesn't satisfy him, for he never resorts to it again. The image, one of his most spontaneous self-portraits, is all line and no modeling: two faint, nearly parallel vertical strokes to conjure up length and width, a crisp horizontal arabesque to convey the fleshy "wings," nostrils, rounded tip, and the merest of shadows on the upper lip (unless it's the fuzz of a fledgling mustache) to give one a sense of the nose protruding from the face. It's really just an ideogram, a conventional sign, not much different from the graphic tradition of medieval noses.

In the *Self-Portrait with a Thick Nose* [ill. 9], another miniature etching of the same year – the year Contantijn Huygens, secretary to the fledgling Dutch republic's ruler, the Stadholder Frederik Hendrik, came to Leiden and "discovered" the town's rising stars, Rembrandt and Jan Lievens – the artist flattens the sides of the nose, emphasizes

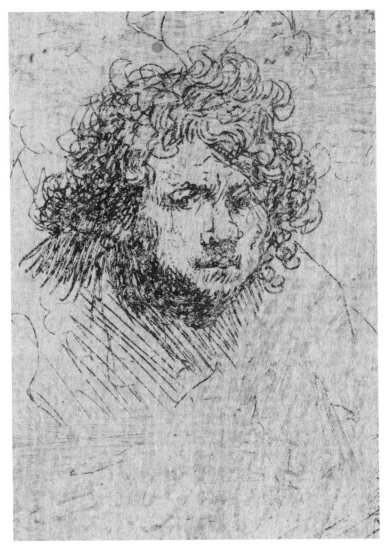

8. *Self-Portrait with Round Face*, 1628. Etching (B. 5. 1). Amsterdam, Rijksmuseum.

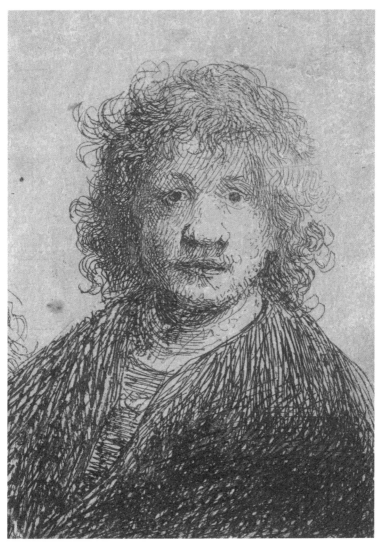

9. *Self-Portrait with a Thick Nose*, 1628. Etching (B. 4). Amsterdam, Rijksmuseum.

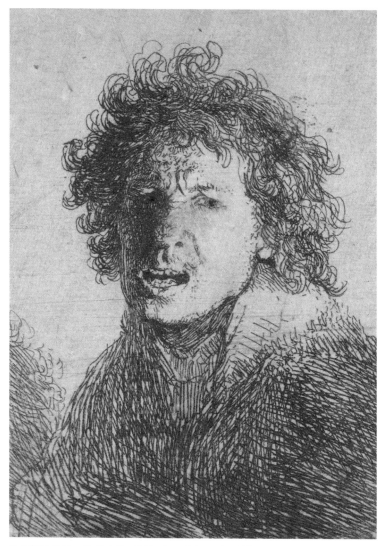

10. *Self-Portrait, Open-Mouthed*, 1630. Etching (B. 13. 1). Amsterdam, Rijksmuseum.

the nostrils, and almost elides the ridge (the etching needle's scratches along the top of the nose are so faint as to be virtually indiscernible). The effect is strangely poignant: a baby face with a nose still unformed and the beady eyes of a small rodent.

However, there is nothing mouse-like about the *Self-Portrait, Open-Mouthed* done two years later [ill. 10], a nightmarish image of the artist as a snarling lunatic. Dividing the face between the nocturnal darkness and raw pallor of a half-moon – the orb of madness – the nose lifts its ladder of vaguely reptilian horizontal streaks above alarmingly exposed nostrils. The sides are swallowed up by a grimace of rage or animal terror. A small round highlight clings to the tip like a bead of sweat – the sweat of a man who wakes from a terrifying dream.

In another, even smaller, etching of the same period, the *Self-Portrait in a Cap, Open-Mouthed* of 1630 [ill. 11], Rembrandt depicts himself struggling to shape his lips around a whistle or, in this case, soundless whisper. This time the light rakes his face, as the knowledge of what makes him flinch and grimace harrows his mind, shedding its glare on the tapering, elongated pyramid of a nose jutting out with an architectural indifference to the storm sweeping the rest of his features. And once again the nostrils are exposed, as if to indicate, like the open mouth and shocked eyes, that the artist is defenseless. He has not donned his armor here, is garbed in no finery or protective camouflage, and has no weapon other than the useless parody of a tusk formed by the shadow cast by his all too vulnerable nose.

The smallest of Rembrandt's self-portraits, an eight-sided, stamp-size etching, also from 1630 [ill. 12], shows him grimacing in disgust, possibly at himself (this is, after all, a rendering of his own reflection

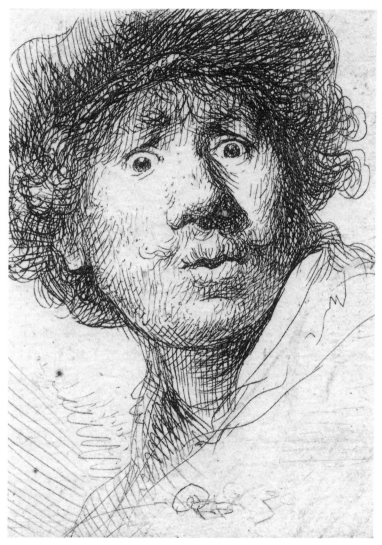

11. *Self-Portrait in a Cap, Open-Mouthed*, 1630. Etching (B. 320). Amsterdam, Rijksmuseum.

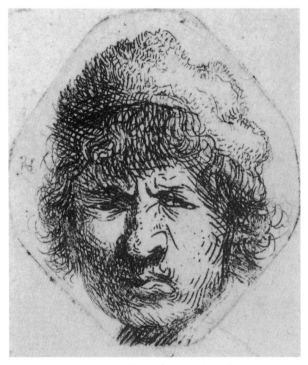

12. *Octagonal Self-Portrait*, 1630. Etching (B. 336). Amsterdam, Rijksmuseum.

in a mirror). The whole face is clenched in revulsion. The nose stands out powerfully, an ugly protuberance on a mask of self-loathing, a microscopic vignette from the artist's last year in his birthplace.

After his move to Amsterdam, these images of the young artist grappling with his art and with himself give way to a string of self-portraits proclaiming an exceptional degree of self-assurance and self-possession. Consider, for example, the relatively large etching,

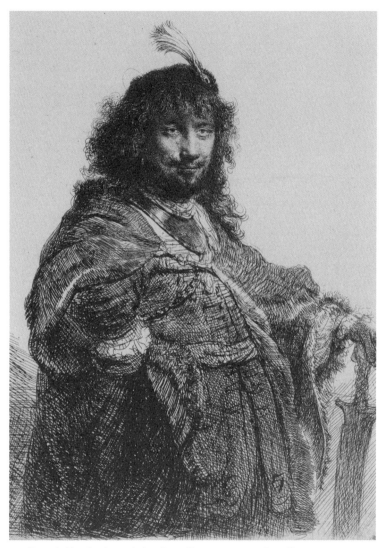

13. *Self-Portrait with a Plumed Hat and Saber*, 1634. Etching (B. 23. 1). Amsterdam, Rijksmuseum.

*Self-Portrait with a Plumed Hat and Saber*, executed in 1634 [ill. 13], the year the artist married the plump and pretty Saskia van Uylenburgh. It casts Rembrandt as a barrel-bellied soldier of fortune, a massive figure recalling one of Dürer's tougher sitters. His right fist is clenched against his hip in a fashionable *contrapposto;* his left hand rests on the grip of his saber. It's the same pose as the one struck by the artist in his self-portrait as a pasha and, even though the foreshortening of the hand on the hip is botched, it looks as convincing as the earlier picture seemed an instance of hollow posturing. The artist has put on weight, literally and metaphorically; his swaggering self-assurance fills the fur-trimmed cloak and breastplate recycled from his earlier appearances as a grand personage. The boldness of this mountain of a man looking down on us is equaled only by the boldness of the hatchings that modulate the folds and highlights of his heavy garments. There is arrogance in the treatment of his great bulk, in contrast to the delicacy of the soft gleams and shadows on the polished steel of the gorget and the wonderfully detailed treatment of the head and the plumed hat. (Rembrandt has once again put the Good Samaritan's aigrette to good use!) The matted, wiry hair, the bristly chin, the watch-spring whiskers, the velvety eyebrows, the nap on the fur hat, the spray of feathers lighter than silk – can they really have been produced by acid biting into a metal plate? Less than a decade after first taking up etching, the artist is showing us that he can do anything he likes with the medium.

Besieged by the tide of curls surging around them, his eyes seem to laugh. The light reflected on the left pupil challenges us to dismiss him. And if we had any lingering doubts about his claim to artistic

supremacy, the blunt power of his nose should set them to rest. (Oliver Cromwell is said to have commanded Rembrandt's contemporary, the Dutch-English artist Peter Lely, to paint his portrait truly, with all its "roughnesses, pimples, and warts." Rembrandt stands before us here, a Cromwell complete with warts on the side of his nose.)[11]

11. In the second state of this print the plate has been cut back to an oval bust. The hatching on the cloak is denser and darker and a shadow has been added to the neutral gray background. Deprived of his sword and swagger – not to mention his formidable belly – the artist looks less like a warlord than an overweight, slightly bedraggled courtier.

# 4

## "This Is Painting, Not Just the Pits and Pores of Flesh."

Color changes everything. In a drawing or etching, textures, tones, shadings, even hues, are rendered with lines, dots, hatchings, and washes. The artist's hand limns, delineates, and defines, conjuring up from the page's blankness a likeness that conveys enough of the "weight," "feel," or visual and psychological density of the sitter to claim our attention as something more than just a simulacrum: not a "portrait" of someone in particular but simply an image that does not need to be legitimated by its sitter. The image suspends the reasonable assumption that a profile is nothing more than a line or succession of connected lines, or that a flurry of strokes in the cavity of an eye is merely a welter of impressions printed from a copper plate scratched with a burin. It presents itself to our eyes as a face, and the fact that it is not an actual face does not diminish it in the least. On the contrary,

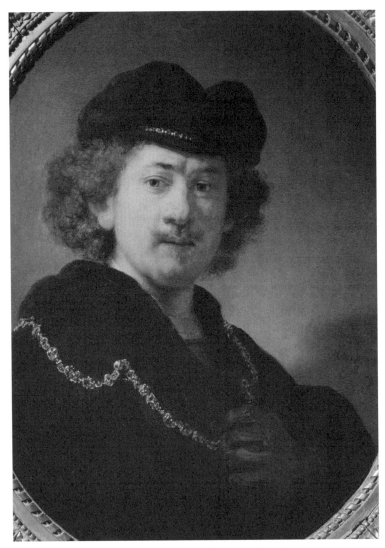

14. *Oval Self-Portrait with Soft Hat and Golden Chain*, 1633. Oil on wood, 27½ × 20⅞ inches.
Paris, Musée du Louvre.

knowing that it is but an accumulation of lines on paper, and at the same time more than the sum of its lines, we draw pleasure from the way it models a nose or the expression of a mouth.

With paint the artist steals one step further into God's workshop. For a palette loaded with pigments brings him two elements that line lacks: color and substance. Building up layers of paint on oak or canvas, covering the prepared ground with dabs of color, flecks and sweeps of juxtaposed and overlapping pigment, the artist's brush fashions a surface that has bumps and wrinkles, minute troughs and crests, or swirls of impasto that are able to convey the puffiness of a complexion or the weight of a lace cuff. In a sense, the worked paint *is* the texture of what it depicts, just as (color and light being inseparable) it is the luster on fur, the liquid glimmer in an eye, the blush on a cheek, or the shadow on a furrowed brow.

Take the *Oval Self-Portrait with Soft Hat and Golden Chain* (1633) at the Louvre [ill. 14]. Rembrandt is twenty-eight now, only five years older than he was in the baby-faced self-portrait of 1628 [ill. 9], yet his countenance could be that of a middle-aged man who worries. He's attired in much the same outfit he wears in the self-portrait in oils of 1629 [ill. 5]: the velvet cape, the soft hat, and the snaking gold braid, now clearly meant to be a chain of royal favor, though it is still only a theatrical prop (Rembrandt has not–and never will–receive such a distinction). He has done away with the plume, perhaps because now that he has a flock of students he feels he has outgrown it–he is no longer a young blade, after all–and has changed the color of the velvet cape and cap to a more sedate dark chocolate, which shows the gold chain to advantage. Surrounded by the twilight tones of the

background and his garments, the artist's head receives the pale light slanting in, as usual, from the upper left, perhaps a gleam of morning sun coming in through a high, mullioned window like the ones Vermeer was to include in his interiors a few decades later.

With a mere handful of colors in a range of muted shades – ochre yellow, white, gray, carmine, green – Rembrandt's brush models the features into the animated expression of a man about to make a remark to which he attaches some weight. Was this the face that peered over the shoulders of his students, pausing for a moment to work out what exactly was wrong with the rendering of this or that highlight or shadow, a patch of color too weak, or a detail handled too timidly? At all events, his brushwork is brilliant here, deft and free (notice the wiry upturned whiskers, the quick diagonal strokes of the eyebrows, the pink streaks in the nostrils and in the corners of the eyes, and the quiver of green and rose defining the irregular ridge of the nose). The paint is laid down in a blizzard of tiny dabs that bring out the texture of the skin, its pores and pits. Colors mold the slightly lumpy face as if it were Plasticine, scooping out the orbital cavities, dimpling the forehead and the corners of the mouth, building up the nose, kneading it, fractionally skewing it so that it becomes a kind of fleshy extension of the quizzical look in the eyes. We almost need to be reminded that the sensual quiver of the lips and the all but imperceptible tremor of the nostrils as they appear to expel a breath are only pigment on a prepared wood panel.[12]

12. A second, slightly smaller panel in the Louvre, painted the same year, portrays Rembrandt in riper, mellower tones, wearing the same velvet cape and gold chain, but hatless. The nose is stubbier, smoother, and slightly bulbous, though nothing like the nose in the artist's last self-portraits.

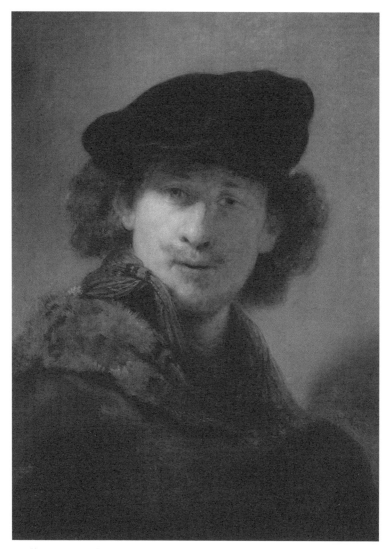

15. *Self-Portrait with a Soft Hat and a Fur Collar*, 1634. Oil on wood, 23 × 18¾ inches. Berlin, Staadliche Museen, Gemäldegalerie.

One has to look twice before connecting the somewhat finicky expression of this self-depiction with the artist's face captured in a flush of vitality and sensuality in the rightly famous *Self-Portrait with a Soft Hat and a Fur Collar* in the Gemäldegalerie in Berlin [ill. 15]. Painted within weeks, or at most a few months, of Rembrandt's marriage to Saskia in the summer of 1634 — surely at the height of their courtship — it concentrates the facial features in a dense patch of jostling, vibrant colors. The ochre yellows, purplish pinks, grays, and bronze greens of the earlier portrait are still there, but they possess an edge and intensity they did not have in 1633, and are applied with a faster, more nervous touch, as if the artist were in a hurry to get back to his girl. The stunning device of the serpentine green silk collar emphasizes the green eyes and green shadows on the chin, jaw, and right cheek. The mouth is impatient, avid for kisses, fame, and money.[13] The light on the left side of the face is full and rich — the light that Jupiter spills over the recumbent female nude in the Hermitage Museum's vandalized *Danaë*. The sitter's nose is flared and canted to one side like the muzzle of a horse champing on his bit. A tiny, pure-yellow highlight glints a few millimeters from the tip, a fleck cunningly set off-center at the precise point where our gaze comes to rest, a little dazed by the helter-skelter of brushstrokes that proclaim, "This is painting, not just the pits and pores of flesh."

---

13. "Il n'aimoit que sa liberté, la Peinture, et l'argent." J.-B. Descamps on Rembrandt (*La Vie des peintres flamands, allemands et hollondois*, Paris: C. A. Jombert, 1753–64, vol. 2, p. 90).

# 5

## An Old Man Slumped in a Wooden Armchair, a Widow Who Surrenders to No Weakness

It wasn't just his own features that Rembrandt kneaded into the expressions he wanted them to have. In the late 1620s and early 1630s he produced a string of portraits of two sitters, an old man and an elderly woman traditionally identified as the artist's father and mother.[14] Whoever they are, they look considerably worn by a life that would have been far from easy (they belonged to a generation that survived the Spanish siege of Leiden in 1573–74, when a third

---

14. With the exception of the caption "Harman. Gerrits." in Rembrandt's hand on the chalk drawing in the Ashmolean Museum in Oxford [ill. 17], there is no hard evidence that this is in fact the case. An inventory drawn up in Leiden in 1644 mentions a "head of an old man, being the portrait of Master Rembrandt's father," but there is no way of knowing which work this refers to or even if the work in question is still extant. As for the likenesses of the "artist's mother," the first mention that she may have served as a model for her son occurs in another inventory, which states that she was the subject of an unidentified copper plate. This was in 1679, "a bit too late in the game . . . to be considered compelling evidence" (Schwartz, op. cit., p. 63).

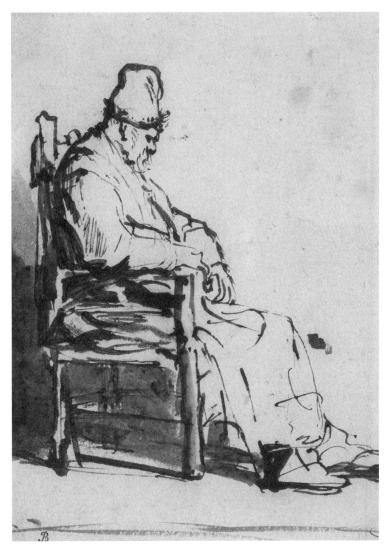

16. *Seated Old Man*, c. 1626. Pen and brush drawing.
   Paris, Musée du Louvre, Département des Arts Graphiques.

of the town's inhabitants died of hunger and disease). If the woman really is Rembrandt's mother, Cornelia (who was in her early sixties when her son left home for good), she has borne no fewer than ten children, of whom Rembrandt is the ninth. The fourth-generation miller Harman Gerritszoon would have been around the same age, a man who had worked hard at a hard trade from early childhood on, and had retired as a result of some impairment, possibly blindness, leaving the management of his mill to his oldest son, Rembrandt's brother Gerrit. Harman died in April 1630 (followed by Gerrit seventeen months later), so if he really is the subject of a number of the artist's drawings, etchings, and paintings from this period, they are portraits of a father in the last few years—even the last months—of his life. (Cornelia was to survive her husband by another decade.)

In a pen-and-brush drawing in the Louvre [ill. 16], executed when Rembrandt was around twenty and still living at home, a bearded old man wearing very plain garb (a thick robe or coat and what appears to be a high wool bonnet) is slumped in a wooden armchair: a grandfather parked in a pool of brightness streaming through a doorway or window while the life of the house eddies around him. Judging from the droop of his hands, the angle of his chin resting on his chest, and the downward pull of his lumpy profile, he has nodded off to sleep.

Perhaps he's the same old man as the sitter, clearly identified this time as Rembrandt's father, in a red and black chalk drawing of about 1630, in the Ashmolean Museum at Oxford [ill. 17]. Here he is depicted full-face. His hat, more like a helmet than a bonnet, is pushed back on a broad forehead; his mouth is all but concealed in a tangle of graying beard; and his eyes are narrowed to slits, like those of a sleeping tabby

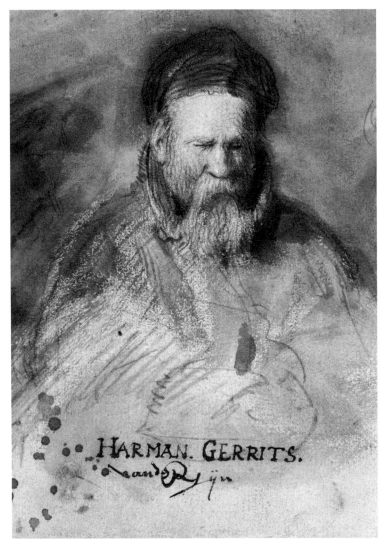

17. *The Artist's Father*, c. 1630. Red and black chalk drawing with brown wash, 7½ × 9½ inches.
Oxford, Ashmolean Museum.

cat, above a short, somewhat flattened nose, which recalls that of the artist in the *Self-Portrait with a Soft Hat and a Fur Collar* [ill. 15]. It has the same small bump on the ridge, the same rounded tip, the same dot-like highlight placed fractionally off-center, and the same shapely, upward-slanting "wings." But, of course, the model is no longer in the full flush of his youth. He has the frail appearance of a man sunk in the sleep of what at the time must have seemed extreme old age.[15] The chill his collar is turned up against could be death itself.

The milky eyes of blindness peer out between inflamed lids in an etching of 1630 traditionally (though, again, uncertainly) identified as a portrait of the artist's father [ill. 18]. The model doesn't look much like the Harman Gerritszoon of the Oxford drawing. He seems ten or fifteen years younger. There are no white hairs in his trimmed beard and his nose appears to be longer, more assertive, almost imperial (and perhaps imperious) amid a thicket of folds and wrinkles that speak of a lifetime of cares and a certain noble resignation.[16] This could be Job's face.

15. Always fascinated by figures of the very elderly, Rembrandt was painting biblical "histories" in the period when he made this sketch, showing canonically old men with bushy white beards arguing with each other or, more frequently, brooding and alone (*St. Paul in Prison*, 1627; *Jeremiah Lamenting the Fall of Jerusalem*, 1630; *St. Peter in Prison*, 1631). The man who modeled these figures had a high forehead too, but was thin-faced and had a long, straight, sad nose.

16. The same features, though belonging to a man in his forties or fifties and quite definitely not blind, appear again in two oils from 1630. In the first, the *Portrait of a Man with a Fur Collar* at the Mauritshuis in The Hague, the sitter, wearing the same soft cap as in the etching just discussed, has the disappointed look of someone who feels he has not achieved what he had set out to do in life. In the second, a portrait at the Tyroler Landesmuseum in Innsbruck, his gaze has a fierce determination below a towering hat that could be the headgear of the artist's father in the chalk drawing. In both paintings, the same long, sharp nose acts as a dike against the encroaching tide of shadows on the right side of the face.

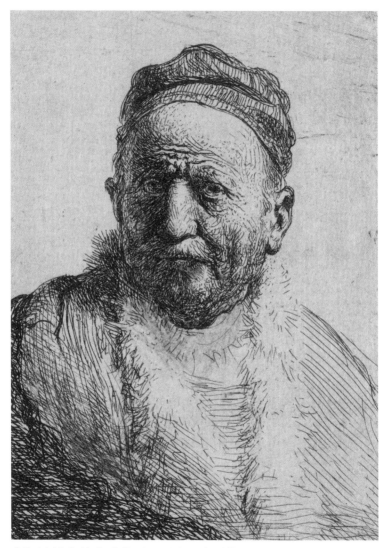

18. *The Artist's Father (?)*, 1630. Etching (B. 304. 1). Amsterdam, Rijksmuseum.

In another, smaller bust etched that same year, the identical sitter wearing the same fur-trimmed cloak or is bare-headed and shown in profile in the slump-shouldered attitude of weariness or somnolence depicted in the two previous works. The nose is long and straight, garnished with a single large wart or pimple on the side; it extends the long slope of the forehead and skull like the nosepiece of an ancient helmet. Yet another etched profile of 1630 [ill. 19] – one of Rembrandt's most prolific years as a graphic artist – again connects the ridge of the nose and the forehead, which is now held perfectly erect, in a classically straight line. The top of the skull is flatter and the back of the head remarkably elongated. To emphasize the model's look of distinction, the fur trim on the coat has been rendered in delicate shades of white – not a retired tradesman's rabbit fur, but the ermine of an important personage. What is more, the artist's beloved gold chain is draped discretely along the edge of the shadow below his shoulder. A *tronie* or a tribute?

A year later, perhaps in the weeks following his father's death, Rembrandt did two further etchings of his parents (as they are assumed to be). These works are almost identical in size, so that one wonders if they were not intended as companion pieces. In the first [ill. 20], an old matron in widow's weeds sits in front of a table, her hands folded in her lap, her head as erect as a grieving queen's, her lips pressed tightly together, her eyes locked in the unfathomable loneliness of the recently bereaved. In other portraits of her (notably the well-known oil of 1630 in a private collection in Germany, an image of a face decomposing in the grave, one might think, but for the half-open eyes, the rawness of the eyelids, the flutter of pink along the bridge of the nose

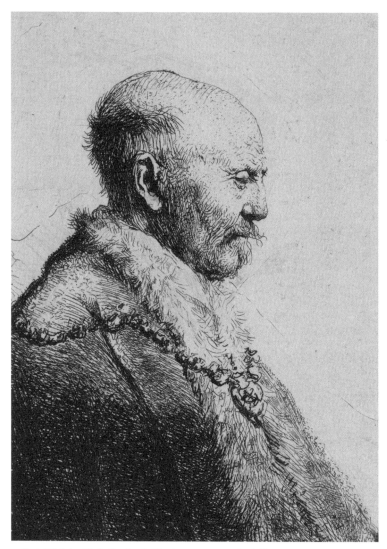

19. *The Artist's Father (?) in Profile*, 1630. Etching (B. 292. II). Amsterdam, Rijksmuseum.

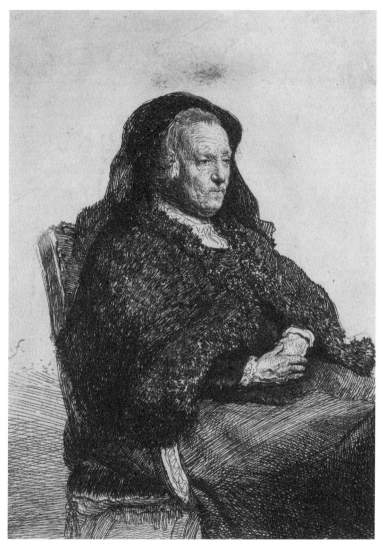

20. *The Artist's Mother with a Black Veil*, 1631. Etching (B. 343.1). Amsterdam, Rijksmuseum.

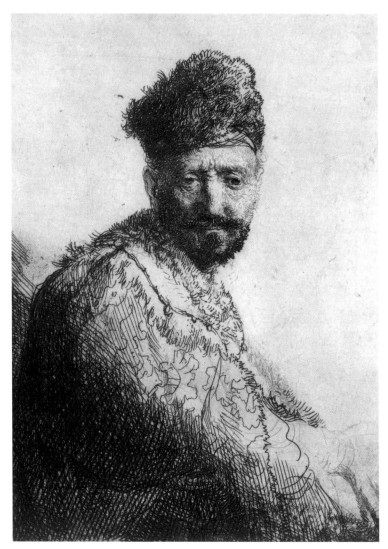

21. *The Artist's Father* (?), 1631. Etching (B. 263. II). Amsterdam, Rijksmuseum.

and on the edge of the almost lipless mouth, and the ochre tones of her crumpled parchment skin), the artist emphasizes details that make her look old beyond her age. But not here. The subject is not flesh crumpling under the weight of time, but the dignity and indomitable spirit of a woman who surrenders to no weakness. In the aftermath of her husband's death and on the eve of her youngest son's departure to a city and a way of life that she may well have disapproved of – for every painter in her day who could boast of a gold chain (and doing so meant behaving as shamelessly as a courtier), there were dozens who loitered in taverns and slept with whores – she was more than ever the matron of the van Rijn clan.

The portrait of Harman Gerritszoon (if that is who he is) is an idealization too [ill. 21]. Presumably, the sitter is now dead and buried, a presence haunting the artist's memory rather than the actual breathing patriarch. Perhaps this is how Rembrandt chose to remember his father, or perhaps it is a gift to his mother and siblings (a framed likeness of the deceased for the parlor mantelpiece?). At all events, here is the old man as he was before failing strength and eyesight furrowed his face. Here he is, sound of body and mind, sporting a trim black beard and mustache, with his kind pensive eyes, long patrician nose (though the bump on the bridge suggests that it might once have been broken), and the familiar gold chain – no miller was ever honored with such a distinction.

## 6

## "And Their Eyes Were Opened and They Recognized Him; and He Vanished out of Their Sight."

Though there were times when his production dwindled to a trickle (as it did in the fateful year of 1653, when the series of events that was eventually to lead him to declare bankruptcy was set in motion), Rembrandt is one of the most prolific painters in Western history. The sheer abundance of his work (not to mention the vast output of his students and imitators) matched that of Rubens and was seldom equaled before the second half of the nineteenth century, when such concepts as spontaneity, capturing the fleeting impression, and speed of execution became marketable values. The body of paintings genuinely by his hand, once thought to number close to a thousand canvases and wood panels, plus a handful of oils on copper, has now been whittled down to less than half that figure, but it is still an impressively large oeuvre, especially once you add the scores of etchings and

hundreds of drawings listed in catalogues of his graphic work.[17] One is struck, of course, not only by its abundance and by the number of masterpieces it includes, but also by the artist's virtuosity in handling a broad variety of techniques and genres (biblical scenes, history paintings, genre scenes, portraits, self-portraits, and so on) and by his habit of returning again and again to certain pet themes, if not obsessions, that link many of his individual works into a remarkably symphonic whole. Given that he earned his living by painting, as his father and forefathers had earned theirs by milling, and that the thriving art market in seventeenth-century Holland dictated the choice of his subjects and even, to an extent, the manner in which he rendered them, it is remarkable how often he went back to what look like essentially private fixations.

If, as it seems, the nose (initially, perhaps, the artist's own nose and then the human nose in general, for its dramatic, architectonic, pictorial, even painterly potential, not to mention its dual nature

17. Just how many of the hundreds of paintings that have been ascribed to Rembrandt at one time or another are authentically by his hand is a much-disputed question. The first great scientific corpus of his pictorial work, Hofstede de Groot's *Catalogue Raisonné of the works of the most eminent Dutch painters of the Seventeenth Century*, published in six volumes between 1897 and 1901, lists nearly 1000 "genuine" Rembrandt paintings. This number was reduced by Abraham Bredius (to 611) in his *The Paintings of Rembrandt* published in 1942, and still further pruned by Horst Gerson in his revised edition of Bredius, which appeared in 1969 (fewer than 500 works accepted). The process of eliminating spurious and doubtful Rembrandts is being pursued by the ongoing Rembrandt Research Project, which has so far published four volumes of the latest, most stringent version of the artist's corpus, covering the years 1625–42 plus all the self-portraits. Otto Benesch's six-volume *The Drawings of Rembrandt: A Critical and Chronological Catalogue* (London, 1954–57) lists over 1,500 drawings and sketches. The etchings are still referred to by the "B" number Adam Bartsch gave them in his catalogue of 1797. Ludwig Münz lists 279 copper plates in his two-volume *The Etchings of Rembrandt* (London, 1952). Christopher White and Karel G. Boon (*Rembrandt's Etchings: An Illustrated Critical Catalogue*, Amsterdam, 1969) put the figure at 286 separate etchings (many of them existing in two or more states).

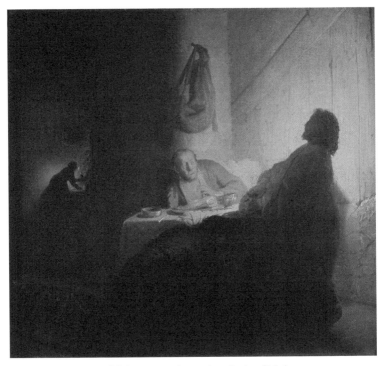

22. *The Supper at Emmaus*, c. 1628. Paper mounted on wood panel, 14¾ × 16⅝ inches.
Paris, Musée Jacquemart-André.

as flesh and as a conduit for breath and spirit) is one such fixation, then surely blindness is another. Whether it was the trauma of seeing his father lose his eyesight, the fear that he too might know the same fate[18] – surely the supreme punishment for a painter – or a poetic

18. A typical Rembrandt portrait is a patch of brightness surrounded by shadows. A shaft of raking light picks out one of the sitter's cheeks, the side of his or her nose, a white lace collar or ruff, or a gold button, while the rest of the figure and the generally neutral background remain all but

fascination with the burden of many a school lesson and sermon in the arch-Protestant Leiden of his youth (the sensuous perception of things is but a false sight compared to the spiritual revelation of the inner eye), blindness, blinding, and a miraculous, paradoxical, seeing-in-blindness are recurrent leitmotifs in his work. And, curiously, they have a connection with Rembrandt's depictions of the nose, and not only because blindness gives an edge to the eye's companion organs of perception (it sharpens the sense of smell as it sharpens hearing: one imagines Homer revelling in the odors of the many-throated sea as deeply as he was hearing it).

*The Supper at Emmaus* (1628, [ill. 22]) is one of Rembrandt's earliest and most theatrical oils. Composed in guttering twilight shades of ochre and black (a very limited palette of colors, even for Rembrandt), it is a stunning demonstration of visual showmanship and, though in some ways a clumsy and self-conscious work, it is nevertheless one of those images that bites into the mind like certain children's book illustrations (no amount of looking at true artworks will ever erase their memory). The scene it depicts, suggested by a verse in the last chapter of the Gospel according to Luke ("And their eyes were opened and they recognized him; and he vanished out of their sight") shows Christ in profile, backlit by a candle or oil lamp, seated at a table in the traveler's inn at Emmaus, where he has been prevailed upon to stop for supper by two of his followers, to whom he appeared as they trudged

indistinct. A face – not even a whole face, but just a few of its prominent features – is islanded in darkness like an actor delivering a soliloquy in a shaft of light. Was Rembrandt's personal predilection for chiaroscuro, lending a spiritual resonance of compositions that isolate a figure in a "cloud of unknowingness," perhaps reinforced by a pathological condition, a shrinking of the visual field as the artist gradually lost his peripheral vision?

dejectedly on the road from Jerusalem on the third day after Christ's entombment. Spiritually blind—so deeply engrossed in their grief and perplexity that they are unable to recognize the Messiah—their eyes are only opened when they sit down at the table with him and he takes the bread, blesses it, breaks it, and hands them each a piece of it. It is this moment of revelation that the painting, so to speak, reenacts.

One of the two men has fallen to his knees at Christ's feet, knocking over his chair in the process—though this is hardly discernible, for he is but a dark shape in the darkness of the foreground. The other recoils in awe and amazement on the far side of the plain wooden table, his hands seared as if from touching the loaf of bread, his jaw dropping, the whites of his eyes virtually popping from his head. He's a clownish, somewhat grotesque figure in this atmosphere of weirdly distorted shadows—a mask of holy terror, the closest Rembrandt comes to an African mask or to the face of one of Picasso's "young ladies" of Avignon: goggle eyes, a black slash for the mouth, and a nose like the tenon on the end of a beam, casting a monstrous shadow.

Everything about him is wooden and too manifest in contrast to the shadowy, fluid, feminine, delicately etched silhouette of Christ leaning back in his chair in the attitude of a genial host entertaining his guests with a string of anecdotes. The light flooding the traveler's awestruck mien, the simple wooden planks of the partition and (apart from the incongruous silver bowl) the workaday objects on the table—a loaf of bread, an earthenware dish, a rumpled napkin, and the extraordinary detail of the gleaming knife poised so tellingly on the table edge it cannot be, one thinks, simply an ordinary knife—outlines Christ's profile and flattens it into a two-dimensional

configuration. And at the same time it seems to emanate from him, especially from a point just behind his brow and eyes. In a paradox as spectacular as the painterly effect expressing it, Christ's head is both as clearly delineated as if it were etched in metal and so dark that it is recognizable only as a profile. You see the fork in his beard, the lock of hair on his forehead, the sharp tip of his nose, but would you recognize the face they belong to in full daylight?[19] The question has the sharpness of a no-frills Calvinist sermon. Its theatrical chiaroscuro thunders: "Are ye not blind ye that have eyes to see with?" Blind as the serving woman in the background, bent over the dull glow of embers in a kitchen hearth. For she is as unaware of Christ's presence in her inn as Breughel's shepherd is unconscious of the headlong plunge of Icarus into the churning sea.

Actual physical blindness (as opposed to unknowing) is central to a score of Rembrandt's paintings, etchings, and drawings inspired by the apocryphal book of Tobit (though, once again, the subject is spiritual perception lost and regained). The story of Tobit and his son Tobias has more in common with the magical atmosphere of *The Thousand and One Nights* than with the Bible. Tobit, an elderly Jew from Nineveh,

19.  These sharply defined features are echoed in Rembrandt's subsequent representations of Christ – especially the *Christ on the Cross* of 1631 at the parish church of Le Mas d'Agenais in France – which are always rendered full-face and never have the same shadowy quality of being at once visible and elusive. Rembrandt returned twice to the theme of the Supper at Emmaus in 1648, but neither of these pictures possesses either the drama or the originality of the 1628 version. (One of them, in the Statens Museum for Kunst in Copenhagen, shows Christ full-face and one of the two disciples, wearing a turban and aigrette like the Good Samaritan, as a backlit profile.) The artist went back one last time to the composition in 1658, giving it a mythological cast as an illustration from Ovid's *Metamorphoses* (*Jupiter and Mercury Visiting Philemon and Baucis*) and reverting without much inspiration to the atmosphere and play of light and shadows in a painting by Adam Elsheimer from 1608–09 which inspired – but was transcended by – the first *Christ at Emmaus*.

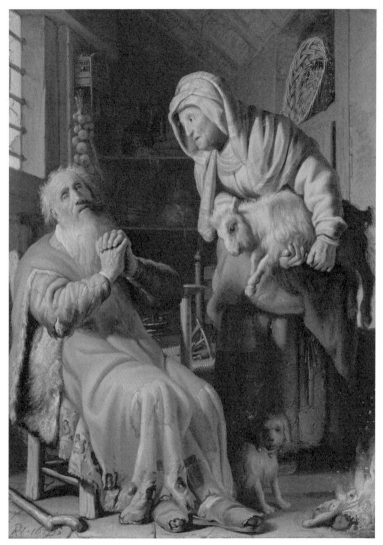

23. *Tobit and Anna with the Kid*, 1626. Oil on wood, 23⅜ × 11¾ inches. Amsterdam, Rijksmuseum.

is an upright, charitable man who is made to suffer an unmerited fate like Job. While sleeping in the courtyard of his house one hot night, he is blinded by sparrows depositing their droppings in his eyes. Unable to travel, he sends his son Tobias on a long and dangerous mission to the land of the Medes to recover some bags of silver he has entrusted to a business associate. Accompanied by a mysterious stranger, Tobias journeys eastward along the banks of a river, but is attacked by a huge fish leaping out onto the dry land, whom he manages to overpower and kill. His companion instructs him to keep the fish's heart, liver, and gall, for they have powerful healing properties. Tobias later uses them to drive out the demon possessing his betrothed Sarah and, after he returns home with his bride and the money, to restore Tobit's eyesight. At this point in the story, the traveler who has accompanied Tobias tells them he is the archangel Raphael. He then unfolds his wings and ascends to heaven in a blast of radiance.

Rembrandt takes up this romantic, surreal story in a small panel from the very beginning of his career: *Tobit and Anna with the Kid* (1626, [ill. 23]). It could be a genre scene—an elderly peasant couple dressed in tatters about to sacrifice what, by the look on their faces, appears to be the last of their livestock (one is reminded of the starving peasant families the Le Nain brothers were painting around the same time in Picardy)—but for the incongruous flames on the plank floor in the foreground, a dog with strangely shadowed eyes transfixed by something or someone (an approaching angel?) directly in front of it, and the poached-egg, cataract-occluded eyes of Tobit. Eyes are the real subject of the painting—eyes and noses. Tobit's look of blank suffering is heightened by the tremor of his nostrils, as if he were being cut

to the quick by the very air he is breathing. Anna's pinched nose is a flesh-and-bones translation of the dismay and indignation in her goggle eyes (Tobit has just accused her of stealing the kid). The dog's snout is like an extruded third eye probing the space in front of the picture, and the sacrificial kid's muzzle and glistening eyeball are the very texture of innocence about to be put to the knife.

The dog is still there when Rembrandt returns to the "Jewish fable" of Tobit (as hard-line Calvinists referred to it) almost ten years later and, once again, in his late thirties and early forties.[20] He approaches it in a variety of modes and moods, from the clinical to the sentimental, teasing its meaning this way and that. In an etching from 1651 [ill. 24], an utterly disoriented Tobit, his mouth open in a shout of welcome or despair and the skin of his face pulled tight over his bony nose and sunken cheeks, stumbles with arms outstretched over Anna's spinning wheel and a snarling terrier toward his own shadow on the wall next to the open door through which he hopes Tobias will return. This is blindness with a vengeance, as terrifying a picture of sightlessness as was ever produced, and the fact that its dizzying flurry of hatchings was obtained thanks to the bite of acid on metal somehow adds to its starkness.

In contrast, a dogless pen-and-ink sketch in the Cleveland Museum of Art (*The Healing of the Blind Tobit*, c. 1645, [ill. 25]) describes what appears to be an actual cataract operation (though one supervised by a ghostly archangel Raphael with unfurled wings). Tobit is again seated

---

20. Rembrandt takes one small liberty with the biblical text: he invariably shows the dog at Tobit's feet (presumably as an emblem of the old man's steadfast loyalty to his faith), where the book of Tobit, which mentions the creature twice, has it accompany Tobias and the angel in disguise.

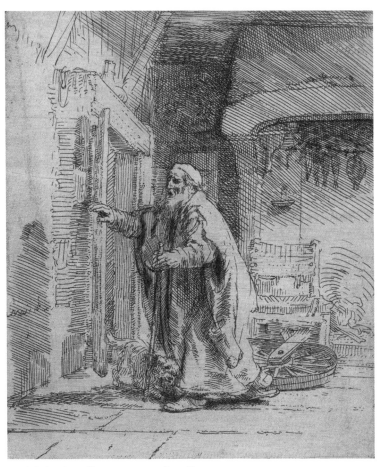

24. *Blind Tobit*, 1651. Etching (B. 42. 1). Amsterdam, Rijksmuseum.

in his sturdy wooden chair, leaning back and gripping the armrests while the only meticulously drawn figure in this otherwise sketchy composition – a trim, young doctor wearing a smock rather than the travel-weary Tobias – incises the lens capsule on his left eye with a needle, the classical procedure for removing a cataract. Amplifying the sharpness of this instrument, the surgeon's nose, echoed by the razor-sharp features of the other standing figures, bores down into the patient's helpless face, which is foreshortened to reveal nostrils as large and vulnerable as exposed eyeballs.

An earlier and far mellower version of the same scene, *Tobias Healing His Father's Blindness* (1636, [ill. 26]), groups four heads, of the archangel Raphael (looking a touch worried), a turbaned and mustachioed Tobias, an even more worried-looking Tobit, and the infinitely loving profile of Anna holding her husband's hand – in a golden oblong of light at the heart of a sleepy vortex of coppery highlights and greenish-blue shadows. In the dim background one makes out broken roof lathes, a half-ruined wooden version of the spiraling stair in the Louvre's *Meditating Philosopher*, a wine barrel, a simmering cauldron on an open hearth, a chorus of seated figures (one can almost hear their whispers in the concentrated silence), an overturned wicker basket, and the hind quarters of a poodle-like dog sauntering away from the miracle taking place by the window.[21] The eye

---

21. The dog is walking right out of the composition as it now stands. Vuillard and Bonnard played with effects like this, but not Rembrandt. A copy of the original composition, in the Herzog Anton Ulrich Museum in Brunswick, shows that it extended some twenty centimeters on the right, and was thus a horizontal rather than vertical panel. The truncated section explains why the dog pays no attention to the miracle being performed on his master: he has spotted something far more interesting – a cat at the foot of a ladder.

25. *The Healing of the Blind Tobit*, c. 1645. Pen and brown ink drawing corrected with white gouache. Cleveland Museum of Art.

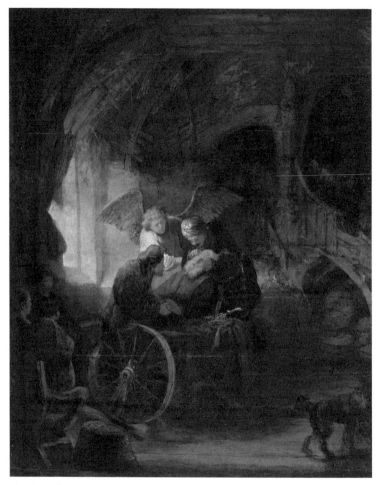

26. *Tobias Healing His Father's Blindness*, 1636. Oil on wood, 18⅜ × 15¼ inches. Stuttgart, Staatsgalerie.

operation itself dissolves in the sweet, dreamy disorder of a universe endlessly turning in on itself like a Möbius strip. It's a lovely, richly textured, strangely musical painting full of secret meaning and hidden depths, at once plain and elaborate, casual and composed, without the breath of a sermon about it or any of the staginess that marks many of Rembrandt's major works. A tide of milky light streams in from the window on the left, washing over the chalky texture of the stone, the gold wings of the angel, and Tobit's finely delineated eyes, nose, mouth, and the silvery curls of his beard; and in the space between his uplifted face and the heads of his three companions, it is transformed into a healing radiance.

27. *The Blinding of Samson*, 1636. Oil on canvas, 80¾ × 107⅝ inches. Frankfurt, Städelsches Kunstinstitut.

# 7

## Like Hounds Closing in
## for a Kill

The same year he painted this gentle meditation on regaining eyesight, Rembrandt, making a similar but even more dramatic use of intense raking light and swirling shadows, executed (in the direst sense of the word) a picture of extraordinary violence, even for an age inured to brutality. It depicts the climax in the story of Samson and Delilah, a tale the artist had tackled once before, back in the days when he and Jan Lievens had shared a studio in Leiden. (Lievens himself had done a couple of paintings based on it, but then it was a favorite subject of seventeenth-century painters.) Unlike that earlier composition, which focuses on Samson asleep with his head in Delilah's lap as a Philistine soldier comes tiptoeing up with sheep shears in his fist, *The Blinding of Samson* of 1636 [ill. 27] is a spectacular, operatic unleashing of blood lust.

Rembrandt takes the underlying erotic charge of the story – Delilah beguiling Samson into revealing that the source of his strength lies in his long hair and his being reduced to impotence when he is shorn by the Philistines to whom she betrays him – but instead of letting the viewer's imagination anticipate the explosion of ferocity, he lays it out in front of our eyes, detail by detail, clenched toes and straining muscles, splashes of blood and iron manacles biting into flesh. This is one of Rembrandt's largest canvases and every inch of it is packed with savagery. In a bold, baroque reversal of the convention that light tones advance toward the spectator while dark ones recede, he pulls us into it by making the foreground shadowy and filling the background with radiant blue and white. This is what Samson is losing, the shimmering brightness of daylight.

But, in the end, the blinding is merely a pretext or metaphor for a deeper, more disturbing level of violence. The real subject here is violation and emasculation. The thrust of the partisan held by the figure in red, angling down between Samson's writhing legs, and the sword gouging out his right eye leave no room for any doubt about what is happening on the symbolic level. The tuft of Samson's beard gripped by the lower of the two soldiers in full armor and the mane brandished like a trophy by the excited-looking Delilah as she rushes from the mouth of the cave – another charged symbol from the subconscious – are equally eloquent.[22] So too are the noses of the different figures in

22. Rembrandt continued to depict himself well into the late 1630s sporting an unruly tangle of long, ruddy-brown hair, as if it were a badge of his strength as an artist. In the 1640s and 1650s he seems to have worn his hair somewhat shorter, but in his declining years he let it grow out again: in the Kenwood House *Self-Portrait* of 1665 [ill. 45] and in the National Gallery and The Hague self-portraits of 1669 it spills out from the sides of a flat bonnet in lanky, gray curls that are a wearier

the composition: they surround Samson like hounds closing in for a kill, blunt noses lunging at the victim. The nose of the soldier lying under Samson, pinning him to the ground, seems about to grind into the stricken hero's head. The nose of the soldier doing the actual blinding seems poised to plunge down and follow the thrust of his sword. The shape and slant of the nose in profile belonging to the partisan-wielding soldier echoes that of his weapon, and is clearly in danger of sharing the same fate as Samson's hair if it comes any closer to Delilah's shears. Even Delilah's girlish, delicately shaded nose strikes a sexual note: it looks naked among this pack of bristling masculine snouts intent on their prey. One barely makes out the nostrils, but one pictures them dilated with arousal.

version of the wiry mop of his youthful self-portraits. Though he never actually portrayed himself as Samson, the manes his bareheaded Samsons flaunted could have been modeled on his hair.

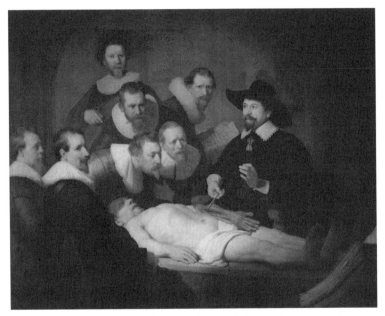

28. *The Anatomy Lesson of Dr. Tulp*, 1632. Oil on canvas, 66¾ × 85¼ inches. The Hague, Mauritshuis.

# 8

## Mournful Nostrils through Which Breath Would Never Pass Again

Once again, figures crowd around a man laid out flat, though he is hardly a hero and is, in any case, long past struggling and suffering. The records tell us that he was a townsman of Rembrandt. In a town of 40,000–50,000 inhabitants, as Leiden was around the time Rembrandt caught the fellow's likeness in death, there is a chance that the two young men, the artist and the thief, both aged around thirty, had been acquainted with each other, at least by sight. Both had moved to Amsterdam not long before this picture, *The Anatomy Lesson of Dr. Tulp* (1632, [ill. 28]), was painted. Rembrandt was seeking fame and fortune as a painter; Adriaen Adriaensz., otherwise known as Aris the "Kid," was pursuing a career as a petty thief that ended on a gallows at first light on January 31, 1632. Afterward, his body was

cut down and carted off to the anatomy theater of the Surgeon's guild for the edification of several of Amsterdam's leading citizens.[23]

For none of the impeccably dressed burghers gazing intently at the "Kid's" cadaver, or rather at the ligaments of his flayed left arm, was a nobody. They were important enough for their names to be listed on the sheet of paper held by the figure wearing a thick ruff. The man performing the dissection, Dr. Nicolaes Tulp, distinguished by the Calvinist sobriety of his modest flat collar and plain black cloak and hat, was a respected physician and the author of a treatise on pathological anatomy. By 1632 he had already served several terms on the town council as an alderman (and would eventually be elected burgomaster) and was married to the daughter of an influential deacon of the Reformed Church. In other words, the group portrait of Dr. Tulp and seven of his colleagues, commissioned perhaps through the good offices of Hendrick van Uylenburgh, was Rembrandt's most substantial group portrait so far and evidence that, only a few months after taking up residence in Amsterdam, he had gained access to the upper crust of Amsterdam society. (He was never to break through to its highest echelons, due to his reputation for bearishness, his questionable business practices, and scandalous lifestyle.)

*The Anatomy Lesson* seems to have been admired at once for the liveliness and naturalness of its individual portraits. No doubt, too, each of the sitters (who may have paid as much as 100 guilders each to have their likeness included in the painting) had reason to feel satisfied: not only had the artist produced a recognizable depiction, but he had also

23. Simon Schama, *Rembrandt's Eyes*, London: Penguin, 2000, p. 351.

caught the essence of what made each sitter a worthy and dignified citizen. To a tradition of group portraits of guild members characterized for the most part by flat compositions and wooden expressions, Rembrandt brought depth, drama, and the compelling illusion that the painting is the record of a significant event witnessed by the artist in person. Whether Rembrandt was actually present or not at the anatomy lesson depicted here, his portrayal of Dr. Tulp and his audience of learned physicians must have involved hours of sittings in the artist's studio. But, of course, what matters here is the way the individual portraits have been combined in an overarching composition and message, for it is the whole, the shared lesson, that gives meaning to each participant.

Such is the look of concentration and wonder on the faces of the attending surgeons that it seems we are being vouchsafed a view of a major physiological discovery. In actual fact, Dr. Tulp isn't coming up with anything that Vesalius hadn't already found. He has bared the cadaver's hand and forearm to show the muscles and tendons in this part of the human body. Lifting one set of muscles with the instrument in his right hand, he seems to be demonstrating the flexor mechanism of the arm with his raised left hand. The real center of the painting – the area to which our gaze is drawn, like that of the figures leaning down to get a closer look at the dissection – is the triangle of space against the darkness of Tulp's black garment between the eloquent vitality of his two living hands, with their stunning foreshortening and the play of shadows and highlights on them, and the strange, inert, mineral beauty of the dead man's hand with its fine white and vermilion streaks.

The meaning that circulates between these three points washes over the whole composition, much like the raw white light beaming down from some hidden source outside the upper left frame – in a sense, it *is* that light, for without light there is no life and movement and the body is merely an intricate bundle of organs, muscles, and bones. This light shines on Dr. Tulp's hands and is reflected alike on his clean fingernails and on the dirty fingernails of the "Kid." It glows on the ruffs and lace collars of the guild members and on the white cloth draped over the cadaver's loins. It glints from the tip of every nose in the composition – the ruddy, eager noses of the living poised like beaks about to strike, and the executed thief's waxy, mournful, strangely elongated nostrils through which breath would never pass again.[24]

24. "What Rembrandt has painted, then, is a moment of truth, another instant in which both the immediate and the eternal stand simultaneously illuminated. Both he and Dr. Tulp would have seen the placard held in the bony grip of a skeleton mounted at the back of the Leiden anatomy theater and commanding *Nosce te ipsum* – 'Know thyself.' It was a motto which both painter and physician would, in their respective ways, adopt for the rest of their lives" (Simon Schama, op. cit., p. 353).

# 9

## Patrician Beaks and an
## Old Lady's Lumpish Snout

Whether it was *The Anatomy Lesson* that made Rembrandt Amsterdam's most sought-after portraitist or whether the surgeon's guild asked him to paint a group picture of its most prominent members because he was already in demand among the city's elite, the fact is that, in a span of three years after settling in the metropolis, he painted some fifty society portraits. A few of his sitters, like the diplomat and adventurer Anthonis Coopal (who wangled the title of "Marquis of Antwerp" from Frederik Hendrik in return for a scheme to take Amsterdam's rival port of Antwerp by surprise), had connections with court at The Hague. Mostly, though, they were prosperous merchants and their wives, or men of cloth, dour and scholarly, prominent in the Reformed Church or the Mennonite brotherhood. Some were Jews, a few were Catholics. But whatever their religion and the source of their wealth,

the men and women who sat for Rembrandt were used to command-ing and getting respect. They were not shy about who they were, or diffident. They knew their own worth – and, clearly, the worth of hav-ing their portrait done by an artist like Rembrandt. What they wanted from the painter is what Dr. Tulp and his colleagues wanted: a good likeness, but one that showed them as they wanted to be seen in the eyes of their fellow citizens. A substantial fee and a recommendation to other socially prominent sitters in exchange for a high standard of workmanship and the materialization of the upright, hard-working, righteous morality that propelled them to a position of eminence – this is what they contracted for. This and something more, a thing for which Rembrandt was miraculously gifted: quickening pigment on canvas or an oak panel, making it live. His patrons and clients did not want to be eulogized or memorialized or made into emblems. They wanted their likeness to look alive.

Almost always the sitter is placed against a nondescript back-ground, more often than not in a garb (usually black) that testifies at once to the importance of his or her social position and bank account and to the fact that he or she attaches little importance to worldly possessions. The massive cut of the garment stands out against the background and sets off a dazzling, white lace collar or ruff on which the sitter's head is presented as if on a platter, freed from the weight of the body and its gross needs. An indefinable shaft of natural light is usually beamed in from some point out of frame to the left and slightly above, so that if the sitter is wearing a wide-brimmed hat, as is often the case with the men, its shadow falls across the upper part of the face, picks out an ear, a cheek, one side of the nose, the lips,

and the chin, and rebounds on the pristine collar, which casts its own soft glow on areas of the model's face – now illuminated both directly and indirectly.

Everything is in the details. They are concentrated in an area that covers less than a quarter of the picture. Or, if they extend any further, it is only to melt into the shadowy indistinctness surrounding the figure, like the sable trim of Nicolaes Ruts' coat [ill. 29] – so glossy and soft on his shoulder, against the crisp waves of the ruff – or the teased curls of Maria Trip's soft brown hair, the delicate gleams of her matching earrings and brooch, and the lace covering her flat chest like layers of frost flowers [ill. 30]. (The elaborately decked-out Maria Trip is something of an exception among Rembrandt's generally low-key models, but then her father, a munitions dealer, had been one of the richest men in Holland and her widowed mother, Alijdt Adriaensdr. [ill. 31], had received the Stadholder's wife Princess Amalia and Marie de Medici on the occasion of the French queen's visit to Amsterdam a year before Rembrandt painted her portrait.) Within the oval of the face, however, nothing trails off and nothing is accessory; every dab and stroke of the artist's brush states who the sitter is, not what the sitter owns.

Consider the bovine self-satisfaction of the fifty-one-year-old Haesje Jacobsdr. van Cleyburg [ill. 32], lapped in her armor of starched white linen, her face as smooth as an egg. Hardly a wrinkle or crease on her face; not a blemish, save for two faint scars at the root of her nose and her left temple. Her skin has the coloring and substance of suet pudding laced with a drop of cherry brandy – the complexion of a woman who doles out small luxuries to her family with a teaspoon,

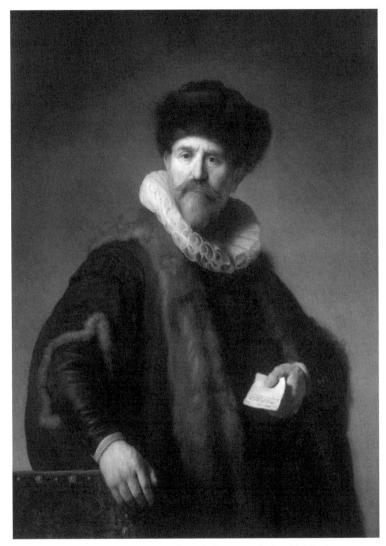

29. *Portrait of Nicolaes Ruts*, 1631. Oil on wood, 46 × 34¼ inches. New York, The Frick Collection.

30. *Portrait of Maria Trip*, 1639. Oil on wood, 42⅛ × 32¼ inches. Amsterdam, Rijksmuseum.

31. *Portrait of Alijdt Adriaensdr*, 1639. Oil on wood, 25½ × 21⅝ inches.
    Rotterdam, Boymans-van Beuningen Museum.

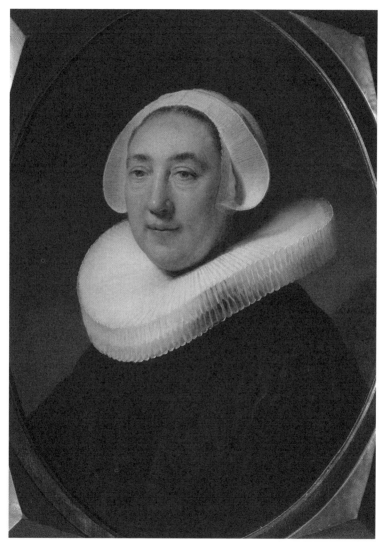

32. *Portrait of Haesje Jacobsdr. van Cleyburg*, 1634. Oil on wood, 27 × 20⅞ inches. Amsterdam, Rijksmuseum.

sleeps soundly, and has nothing about which to reproach herself. Her nose, long and regular and as straight as a broom handle, with the merest hint of rose outlining the "wings," shines softly like polished wood and metal. There is even a tiny highlight glinting from the wall of one of her nostrils, as if it had been deposited there by a lifetime of smelling soap and wax, though it is in fact the reflection of the light glancing off her ruff. The sharpness of details like this – the streaks of gray in her tightly combed hair, the faint striations and halftones on her coif and collar, the almost imperceptible divergence of her pupils – carries such a feeling of truth that, at first glance anyway, one never stops to wonder whether the painter might not have earned his fee by removing a dozen years from the sitter's face.

One of the secrets underlying Rembrandt's society portraits of the 1630s – clearly one of the reasons why he was so sought after as a portraitist in his early Amsterdam period and why his likenesses of individuals who died some three-and-a-half centuries ago still hold our gaze – is their balance of the two seemingly irreconcilable demands of idealization and honesty or, put another way, timelessness and truthfulness. They simultaneously suspend the sitter's face in a moment of eternal clarity, a beam of clean light that will never shift, and materialize the effect of passing years on the sitter's expression and complexion.

Rembrandt cleaves to classical conventions of portraiture with respect to lighting, the sitter's pose, the shape of the head, and the treatment of the features. The forehead, for example, is nearly always high and rounded (especially in female likenesses); the nose long and narrow (a cliché of good breeding); the eyebrows thin and arched;

the eyes sharply focused; the mouth straight and never more than slightly ajar. The face is framed by the sitter's headgear and collar to form a nearly perfect oval. What distinguishes Rembrandt from most other painters of his era is that within this prescribed framework – like Shakespeare packing the fourteen lines of his sonnets with his incomparable use of words – his brush evoked the wear and tear of time on a drooping eyelid or sagging cheek, the lean gray hairs of an aging eyebrow, or the coarse, mottled skin on the back of an old man's hand, with the same extreme sensitivity to minute details of texture as it brings to its loving renderings of fur, velvet, and cambric.

The eyes of an anonymous girl in one of Rembrandt's earliest three-quarter length Amsterdam portraits (it is still signed with his youthful RHL signature, [ill. 33]) peek out somewhat uncertainly from a face shaped like an upside-down teardrop. A plain girl, she is nonetheless perfect and needs no other adornment than the exquisitely geometrical proportions of her head. Yet from a certain weakness around her mouth and chin, from the heaviness of eyelids which match the line of her nose and right eyebrow and, in a second visual rhyme, the ellipse of her forehead standing out against the background, we get an inkling of how she will age.

In contrast, the "poignant venerability"[25] of the eighty-three-year-old woman (perhaps the widow of a Remonstrant preacher imprisoned in 1624) Rembrandt portrayed during his third year in Amsterdam is due not only to her tired eyes and to the weight of flesh tugging her

25. "The effect of the slightly unfocused melancholy that comes from [the] moist and weaker eye being set on the brighter side of the face is crucial to Rembrandt's effort to create, through the slightly downcast gaze, a mood of poignant venerability" (Simon Schama, op. cit., p. 339).

33. *Portrait of a Young Woman Seated*, 1632. Oil on canvas, 36¼ × 28 inches. Vienna, Akademie der Bildenden Künste.

features downward in an expression of lucid melancholy, but also to the phantom of youth ghosting her face [ill. 34]. The burst veins and flabbiness of her cheeks whisper of a complexion that was once rosy and plump. Her forehead has not entirely lost the luster it had in the time when her skin was as tightly drawn as the underside of a wrist. The translucent "wings" of her bonnet seem more girlish than matronly, their material as sheer as a wedding veil and their rendering as delicate as any of Rembrandt's evocations of airy fabrics. Yet what these elaborate folds of fine cambric appear to deride is the lumpishness of the pitted, bloated nose that sits in the middle of the old woman's face like an unwanted guest. The fastidious exactness of the drawing around the edge of the bonnet – a monstrous parody of the twin cavities of the nostrils – mocks the rough yet equally fussy handling of the coarse flesh on the tip and sides of the nose. The contrast is cruel, yet this is not a cruel portrait. The bravura play of halftones on the right side of the sitter's face illuminated by the reflected brightness of her ruff is full of tenderness. In the end, one is not really sure where the light comes from in this portrait: from above or below, outside or within. Logic tells us that it is beamed *on* the old woman's face, but in a sense too it is beamed *from* it.

The rich who knocked – or sent their servants to knock – on Rembrandt's door and commissioned him to paint their portrait (and often too a portrait of their wife) were pioneers of the global economy. They imported furs from Muscovy or spices from Sumatra and sold or traded them for casks of Bordeaux wine, which were shipped to Sweden where fine Swedish steel was to be had, from which they manufactured weapons that could in turn be exchanged for cargoes of wheat.

34. *An Eighty-Three-Year-Old Woman in a Small Ruff and a White Cap*, 1634. Oil on wood, 28 × 22 inches. London, National Gallery.

In an era when southern Europe was subsisting on the edge of starvation, these men accumulated immense fortunes shipping grain from the Baltic to the Mediterranean. Between them, they concentrated much of the world's trade and credit in their hands. Theirs was a plutocracy of nouveaux riches bourgeois, entrepreneurs who in a matter of years became wealthier and more influential than hereditary princes solely by virtue of their financial acumen, commercial flair, and resoluteness. So it is hardly surprising that the features Rembrandt emphasized in his portraits of them were the ones commonly associated with those gifts: the eyes, nose, and jaw.

He has a trick of wrapping the light around the sitter's face, almost always from upper left to lower right, giving prominence to the ridge of the nose and a shadowy depth to the eye sockets. The actual source of the light is always invisible, always out of frame; and the features that catch its radiance, milky and cold in the *Portrait of Nicolaes Ruts* [ill. 29] or warm and sluggish like poured honey in the *Bearded Man* at the Norton Simon Art Foundation [ill. 35], seem to possess a luminous intensity of their own. This gives them an undue presence on the panel or canvas; there is a kind of lust or greed in the way they hoard the richness of the light, and it literally disfigures – or refigures – their visage. Consider the likeness of the well-to-do cloth merchant Nicolaes van Bambeeck (whose wife, Agatha Bas, the daughter of one of the regents of Amsterdam and a director of the Dutch East India Company, also sat for Rembrandt): his face, shown in three-quarter profile, is almost entirely eclipsed by the left side [ill. 36]. It could escape our notice entirely were it not for the right eye boring into us darkly and steadily and the twisted tusk of the nose standing out with dramatic

35. *Bearded Man in a Wide-Brimmed Hat*, 1631. Oil on wood, 27¼ × 21⅝ inches.
Pasadena, California, Norton Simon Art Foundation.

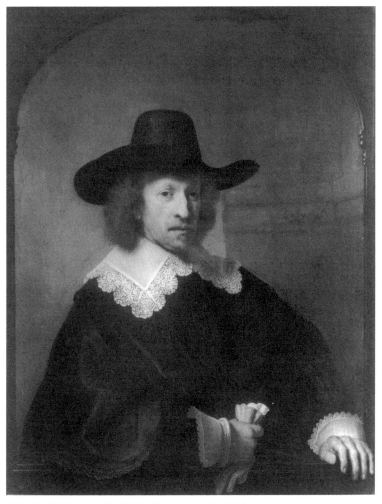

36. *Portrait of Nicolaes van Bambeeck*, 1641. Oil on canvas, 41½ × 33 inches.
Brussels, Musée des Beaux-Arts.

37. *Portrait of Agatha Bas*, 1641. Oil on canvas, 41⅜ × 33 inches.
London, Buckingham Palace, Collection of Her Majesty Queen Elizabeth II.

sharpness against its own shadow. What we are seeing in this portrait, then, is at once less and more than a face: a fragment of a face no larger than the flat lace diamond of the collar which sets it off, yet it's all we need to know the temper of the sitter's character and intelligence. This is someone sharp, and hard too, no doubt; a man who gets his way and is instantly obeyed at home as well as in the counting-room (as is clear from the likeness of the submissive, whey-faced Agatha Bas, [ill. 37]). The contrast could not be more vivid: not simply between husband and wife, but also between the incredibly delicate rendering of the collar—one can almost distinguish its individual threads—and the no less detailed treatment of the face (notice the pinprick catch-lights on his upper lip and eyelids, the rawness on the ridge of his nose, and the play of halftones in the remarkably large left nostril).

Sharpness is everything in these likenesses of self-made men. They are as highly defined and focused as any portrait produced by means of brush and pigment, and the faces themselves are unforgettably keen. Even the round-visaged Marten Looten [ill. 38], another cloth merchant and a convert to the austere Mennonite creed, is given an appearance of acuteness that is at once physical and intellectual. His trim mustache and pointed beard, the angle and crispness of his plain collar and the folds of the letter he is holding in his left hand, the pronounced ridge of his nose and sharply etched crow's feet radiating from the inner corner of his right eye, even the pointed tip of his exposed ear—they proclaim the nature of a man who misses nothing. More than anything, he is defined by the sharpness of his gaze and the fact that his glance is directed toward some point beyond our left shoulder rather than directly at us. He is not looking into us or revealing

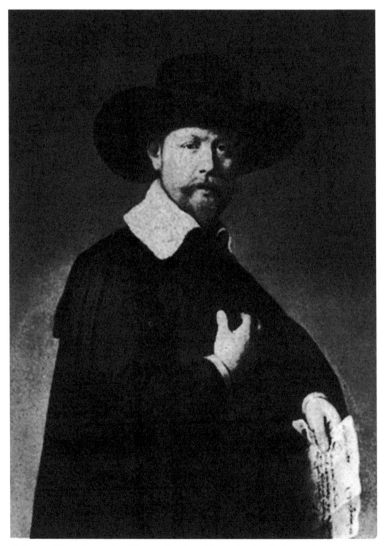

38. *Portrait of Marten Looten*, 1632. Oil on wood, 35⅞ × 29⅛ inches. Los Angeles County Museum of Art.

himself to us. The portrait is not about that kind of intimacy; instead, it's about a quality of mind, or perhaps simply an awareness – an aliveness to the world – that seems to depend neither on the viewer nor on the artist (or so we are led to believe by the fact that it presents itself as a commissioned likeness of a sitter identified by the name at the top of the sheet of paper he is holding). It's the portrait of a man, to be sure, but above all it's the portrait of a temper (in the sense that a steel blade is tempered).

There are tricks and conventions in any portrait. What characterizes a Rembrandt portrait is a combination of painterly and stylistic devices that occur, to be sure, in likenesses produced by his masters or contemporaries – Titian, Rubens, Hals, Van Dyke – but are so tightly woven together by Rembrandt's brush that his likenesses have a look of their own (so distinctive that it was easy to copy and spawned an almost endless succession of "Rembrandts" by his pupils and imitators). But above and beyond all the obvious devices – the three-quarter profile with the head turned one way and the body another, the concentration of raking light on a restricted portion of the sitter's face, the play of smooth and rough shapes, the association of minutiae and brushstrokes as fast and free as lightning bolts, the dramatic tessellation of light and dark areas, and so forth – the trick of projecting the sitter's attention beyond the viewer, or deep within his own thoughts, is the most fascinating. It's as if the sitter, like a cat hearing a mouse stirring behind a wainscot, was noticing something that is on the point of becoming apparent but has not yet revealed itself. (And since religion imbued every aspect of the society Rembrandt lived in and painted for, one immediately thinks of the

word "immanence": Rembrandt's sitters, whether they are preachers or businessmen, all look attuned to the pervading presence of God – or money.)

How does he do it? The breath of drama that animates a Rembrandt portrait is produced not just by stunning contrasts in the sitter's garb (white collar, dark cloak) or, more seldom, by an element of theatricality in the pose. Rather, it is suggested by a kind of discontinuity at the very center of the sitter's face, essentially in the area between the eyebrows and the tip of the nose, where the light is strongest and the shadows are most eloquent. Baroque chiaroscuro amplifies the effect, but the effect is not produced by chiaroscuro. Look closely and you will notice, in nearly every one of Rembrandt's portraits, a minute shift of the sitter's pupil and iris from the orientation that at first glance one would expect them to have. Usually they appear to have moved a hair's breadth toward the source of the light, and sometimes the least shaded eye seems afflicted with a strabismus so slight as to be almost unnoticeable – yet sufficient enough to hint at motion, if only the motion of thought. And this motion is invariably opposite to the thrust of the nose: when the sitter's eyes focus on some point in space on the right, the nose points toward the left, and vice versa. What is more, the nose, given prominence by the fact that it is powerfully illuminated on one side and casts a strong shadow on the other, projects outward, while the eyes appear to sink into the shadowiness from which the sitter is simultaneously rescued by the artist's brush and allowed to recede. The gaze is elusive; it brims with meaning yet isn't really decipherable. The nose is manifest, tangible – one feels one could reach out and touch it – and, if

anything, it's a little too fleshy and obvious. Its shape, colors, and the very substance of the pigment with which it is painted present themselves to us more vividly than do those of the sitter's other features. The nose is sensual in a way the eyes never are. One can almost smell the odors it smells (linseed oil and the fat tang of freshly mixed paint, a faint redolence of pitch, fish, and sea drifting in through the open window of the artist's studio).

There stands Jan Six [ill. 39], for example, as substantial a figure of a man as he was in real life, no doubt. (The large, almost square three-quarter-length portrait appears to be life-size.) The year is 1654, one of Rembrandt's most prolific, the year he painted his masterpiece *Bathsheba with King David's Letter* [ill. 40]. His financial difficulties have begun (the disaster of his insolvency lies two years in the future), and only a few months earlier Six had lent him a large sum of money, interest-free, to help him stay afloat. Six is wealthy, but he is not the usual prosperous Amsterdam merchant with a large purse and a small store of culture. He is a Renaissance man, a poet, a connoisseur of the classics, the author of a published version of *Medea* (for which Rembrandt etched a frontispiece), a Maecenas. In a couple of years he will marry one of the daughters of Nicolaes Tulp – Amsterdam society is a small world – and in due course he will become a burgomaster. He and the artist can converse about higher things.

Rembrandt has already done several drawings of him and an etching in 1647 showing Six with his back to a window, reading a manuscript in a flood of sunshine – a refined, fine-boned young patrician striking just the right balance of nonchalance and fastidiousness. There is something birdlike about the young Six's appearance, especially his

39. *Portrait of Jan Six*, 1654. Oil on canvas, 44⅛ × 40⅛ inches. Amsterdam, Six Collection.

narrow chin and beak-like nose: this is clearly not the kind of reader who will let a detail slip past his notice.

A few years have passed. Rembrandt is now forty-eight, Six is thirty-six. Both men are at the height of their powers and are so confident of themselves that the portrait gives one the impression it was unpremeditated, a sketch tossed off in a flash of inspiration (which of course it is not – for all the freedom of its brushstrokes, it's as thoroughly worked as the meticulous portrait of Maria Trip, [ill. 30]). Rather than appearing to collaborate with the artist by holding a lengthy static pose, Six looks as if he had just gotten to his feet and was about to leave. Rembrandt has caught him in the act of pulling on his left glove, his coat draped negligently over one shoulder, providing the artist with a magnificent pretext for animating the right side of the canvas with cascading scarlet, black streaks, and a crazy ladder of horizontal yellow strokes that remind us more of a Zen calligrapher's brushwork than that of any Western artist before Monet. The sequence of hues is stunning – the deep black-brown background, the pigeon-gray coat, the white froth of the lace cuffs against the flesh tones of the hand and the ochre glove, the streaks of the gold trimming on the cloak's luscious red – but even more stunning is the appearance of reckless spontaneity with which they have been laid down. There are streaks of pigment that look as though they had been flung carelessly onto the canvas, yet their touch is perfect. The treatment of the bottom two-thirds of the portrait is so daring and seems so rapidly executed, it's as if the artist were anticipating the sitter's departure and purposeful stride out into the sun.

The handling of Six's face, in contrast, is meditative, almost brooding. The expression is at once thoughtful and irritable: the inward look of the eyes, the frown, and the hint of tautness around the jaw and mouth seem at odds – the kind of expression one sometimes glimpses on the face of a politician or company executive who is asked an awkward question. For once, there are no shadows on the side of the face; positioned at an angle to the viewer, Six is facing the light almost squarely, albeit with a slight tilt of his head as he considers the words he is preparing to utter. This is no longer the slender, slightly foppish gentleman-scholar of the 1647 print. The physiognomy here is fleshy, squarish, blunt – something of a departure from the sharp features of Rembrandt's usual male sitters – troubled, to be sure, but unshakeable. As if to underscore this, the light is beamed straight onto the ridge of his nose. And what a nose! The base is broad, nearly as wide as the mouth, and, judging from the deep shadow on the upper lip, it juts out powerfully, emphasized by its length, straightness, and the steep angle of its visible pyramid-like structure. One is reminded of an element of military architecture, a bastion or glacis. It's the most masculine nose Rembrandt ever painted and is all the more striking in that there's a suggestion of feminine disappointment in the weary eyes, the incipient sag of the cheeks and chin. The nose has something static and monumental about it: in this portrait where the sitter's restless energy has become absorbed, so to speak, by the restless energy of the artist's brush, it is the point where all the forces in the painting come to a standstill.

So what *has* Six decided to say to his friend Rembrandt? Is it something to do with the fact that Rembrandt has not paid back a single

guilder of the large sum he owes him, that notwithstanding the fact
that the artist's financial affairs are going from bad to worse he is still
spending freely, buying up artworks and curiosities for his private col-
lection even as he risks losing the roof over his head? Does Six see
the looming disaster his friend stubbornly refuses to do anything
about? Or is he about to warn him of the folly of persisting in living in
"whoredom" with his (by now very obviously) pregnant housemaid
Hendrickje? Perhaps in the end he will say nothing about any of this:
Rembrandt is pig-headed; there's no reasoning with him. Six will pull
his right glove on and, after instructing the painter to deliver the por-
trait, he'll step out into the watery light of Amsterdam, where his
future lies. He won't come back to the studio.[26]

26. Rembrandt never repaid his debt to Six. Losing patience with him, Six transferred the debt
to a third party a year or two later. Within a few months of Rembrandt's completing Six's portrait,
Hendrickje Stoffels was summoned to appear before the Reformed Church council to answer the
charge that she was sleeping with her master. In the fall of the same year, a daughter was born
to her and Rembrandt. As for Six, we have no further record of any contact between him and the
artist. When he married Dr. Tulp's daughter in 1656, he commissioned another painter to do her
portrait. Nonetheless, he obviously set great store on his portrait by Rembrandt, and even com-
posed a couplet about it: "This was my appearance, Jan Six / Who worshipped the muses from
youth." The painting still hangs in the Six Collection in Amsterdam.

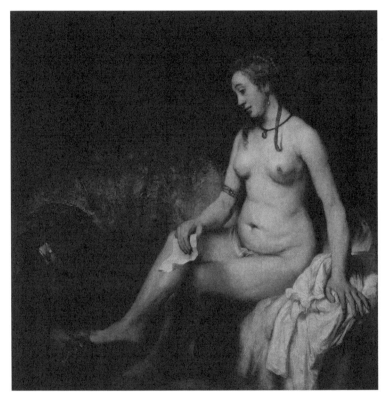

40. *Bathsheba with King David's Letter*, 1654. Oil on canvas, 55⅞ × 55⅞ inches. Paris, Musée du Louvre.

# 10

# Plump Breasts, Firm Skin, and a Profile
# That Makes You Want to Cry

This time he chose a format squarer and slightly larger than the one he had used to portray Six, and once again he pushed the figure to the right of the composition, adopting a low point of view and angling the pose away from the viewer and into a shower of light from a source above and to the left. But the model for this canvas, probably painted within weeks of the portrait of Six, was less than a nobody in Amsterdam society. She was simply Hendrickje, the daughter of an army sergeant. She had entered the artist's household a few years earlier as a maid and in due course had replaced his housekeeper Geertje in his bed, and Geertje had been forced to leave; here was Hendrickje entirely naked and, judging from her heavy waist and the fullness of her breasts, in the early months of her first pregnancy [ill. 40].

Given the context – Protestant Amsterdam in the mid-seventeenth century – it was a provocative work. (Gary Schwarz suggests that it may have contributed to the Reformed Church's severity toward Hendrickje.) Yet although it depicts a pretty young woman who has become an object of lust, and moreover depicts her with a sensuousness that would move a stone (it is hard to imagine a detail more physical than the red ribbon touching her breast or the contrast between her white thighs and the tawny shadow on her left leg), its eroticism is tragic. For the subject of the painting is Bathsheba being prepared for King David's bed. The old woman washing Bathsheba's feet is a familiar figure in seventeenth-century painting: the wrinkled procuress who acts simultaneously as a broker for a lustful transaction and as a reminder of how time ravages flesh (you might say she sets the price on flesh and undercuts it at the same time). In Bathsheba's hand is the summons to the royal palace the crone has delivered to her, and it is not a summons she can refuse. The minute King David spied her naked as she was bathing, her body ceased to belong to her (and still less to her husband); the royal "invitation" is merely a confirmation of this. As if to underscore the notion that desire at its rawest is already a kind of possession, Rembrandt's painting collapses together two separate episodes of the Bathsheba drama: the arousal of King David's lust and the transformation of Bathsheba into his concubine-to-be. What is more, unlike most of Rembrandt's unclothed female figures, which are simply ungainly, this nude and the related *Hendrickje Bathing* in London are, for all their stockiness, deeply appealing.[27]

27. *Hendrickje Bathing* was painted in the year following the completion of *Bathsheba with King David's Letter*. Its format is much smaller and more rectangular. Nevertheless the two compositions are

But the anecdotal background of *Bathsheba with King David's Letter* hardly matters. The painting would lose none of its power, and very little of its meaning, were we ignorant of the verses from the second book of Samuel on which it is based. For the model's profile, and more particularly the line from the base of her nose to the top of her smooth, beautifully domed forehead, tells us everything: the sadness and sensuousness of a young woman whose beauty is not a cause for celebration, but rather a foreshadowing of grief. Sharply drawn against the dark background – the gathering darkness, for this is surely an evening scene – the profile looks etched and two-dimensional compared to the full, rounded treatment of the body. The face, or rather the expression of its lowered gaze and eyebrows arched in a kind of wondering sorrow, is summarized by this outline, which abstracts it from the model's ripe anatomy, her lustrous skin, and plump chin. So what we have here is really the reverse of Rembrandt's usual practice: instead of building the sitter's face around its most carnal feature, he now renders the nose and forehead as a graceful arabesque, a sublimation of her earthly beauty.

To heighten this effect even further, Rembrandt contrasts her profile with that of the old woman washing her feet, and though it is easy to miss it at first (for the old woman's visage is as shadowy as Bathsheba's is luminous), our eye is automatically drawn to it by the diagonal slant of Bathsheba's gaze and her right arm and leg.

related: not only are they based on life studies of the same model, but also the same richly embroidered robe appears in the background of both. Both figures are plunged in a deep meditative hush, though there is nothing tragic about the stillness of the later picture – Hendrickje gazes at her own reflection in the water with a childlike wonder and innocence. Nothing can touch her. Whether Rembrandt planned it that way or not, she redeems Bathsheba.

Notice the difference in the treatment of the two noses: Bathsheba's is a smooth, delicate silhouette; the old woman's is boney and sculptural. The two profiles are by no means identical and they face opposite directions, but they have the same tilt, the same chin, the same look of resignation, almost the same arched eyebrows. Yet while Bathsheba's features possess a kind of mobile plangency – they're the visual equivalent of a dirge – the old woman's are an implacable mask. Her nose in particular looks so sharp and severe her face could be the mask of tragic necessity.

Some nine years earlier, Rembrandt did another painting of a young woman in an erotic pose and again the narrative pretext appears to have been a biblical story. The model was very possibly Hendrickje's predecessor Geertje, but here the subject is not a woman lusted after but a woman lusting. She is in bed, wearing only a nightshirt that has slipped from one of her shoulders and leaves most of her ample right breast exposed. She is leaning forward, almost out of the picture frame, into the viewer's face, pushing back the scarlet curtain of her four-poster bed. (The curtain is flush with the surface of the canvas, so it could also be the kind of curtain that was affixed to the frames of particularly sacred – or excessively profane – pictures.) Rising up from the young woman's shadowy lair, her left hand extends in front of the curtain. Her stubby fingers and huge, shadowy palm seem almost to reach out from the painting, as though they were about to grab us by the lapel and pull us in. There is, in any case, little room for doubt as to her intentions, and most Rembrandt scholars agree that the picture represents Tobias' bride welcoming him to her bed on their wedding night. If this is indeed the subject, the image is unsettlingly

ambiguous: is this the demon-ridden Sarah whose previous seven husbands died in her arms, or is it the Sarah restored to innocence by her groom fumigating the nuptial room with the burning liver and heart of the fish that had attacked him on his journey?

Either way, the sheer carnality of the *Young Woman in Bed* [ill. 41] overwhelms the composition. The fine lacework on the edge of the bolster, the row of tassels along the bottom of the curtain, the elaborate bedstead, the fillet in the woman's hair: these are lovely, but they are not the details our eyes are immediately drawn to. What we notice first and foremost is the abundance of flesh on her thick upper arm and torso, the high color of her cheeks, the pink glow of her lips, the gold curls purling her slightly sweaty brow. We notice the rich play of halftones on her cheeks and chin, the shadows and reflected light on her immense hands, the expectant look in her liquid brown eyes. And of course we notice her nose. How could we miss it? For, as usual, it's right in the path of the light. It's short and stubby, bumpy and somewhat flattened, as if it had been broken by a kick or blow in the face—the nose of a blowzy, rough-and-tumble kitchen maid in a country inn. It's not a beautiful nose, but the faint pink tinge of the "wings," the reddish streak above the tip (a scar?), the receptive oval of the only nostril exposed to our view give the face an unforgettable animal vitality.[28]

28.  Roughly a century after Rembrandt painted the *Young Woman in Bed*, the Geneva banker and art collector François Tronchin was so taken with this work that he commissioned the artist Jean-Etienne Liotard to do his likeness seated next to it (*François Tronchin*, 1757. Pastel on vellum, 38.1 × 46.3 cm. The Cleveland Museum of Art). A virtual double portrait of an art lover and a beloved artwork in the tradition of joint husband-and-wife portraits, Liotard's pastel transmutes Rembrandt's fleshy seventeenth-century lustiness into an elegant eighteenth-century evocation of the lust for possessing art.

41. *Young Woman in Bed*, 1645. Oil on canvas, 32 × 26¾ inches. Edinburgh, National Gallery of Scotland.

That Rembrandt was aware of the sexual connotations of noses seems obvious, judging from an etching made around the time he painted the *Young Woman in Bed*. The *Ledikant* of 1646 [ill. 42], or *The French Bed*, as it is called, is one of the artist's "naughty" prints (the others include a monk tumbling a peasant girl in a wheat field, a peasant woman urinating copiously, and a shepherd boy peeking under a country wench's skirt). It shows a man and woman, breeches down and skirt rucked up, making love in a capacious canopy bed. There was a market for such items in Protestant Holland. But the remarkable thing about this print – besides the delicate rendering of the light and dark areas distributed around the black patch where the lovers' bodies are joined – is its hushed atmosphere. Pornographic images are noisy – all those grunts and moans – but the couple in the *Ledikant* are as quiet as mice. They gaze at each other wordlessly amid their entangled limbs (so tangled that, on close inspection, one notices that the faintly smiling woman is in fact favored with two left arms). Their noses are almost touching: hers is raised, a snub nose, its nostrils wide and offered; his, long and swollen at the tip, looks as if it was about to penetrate her.

Rembrandt returned to the theme of a young woman in bed in one of his last prints. He was fifty-three, on the threshold of what in the seventeenth century was already old age, a grizzled survivor. He had lost his wife and three of their children; his arrogance, inability to repay his debts and scandalous private life had alienated his most powerful patrons, including Jan Six; his town house on prosperous Sint-Anthoniebreestraat and most of his collection of artworks and curiosities had been auctioned off to his creditors, and he

42. *The French Bed*, 1646. Etching (B. 186. II). Amsterdam, Rijksmuseum.

was now living with Hendrickje and his son Titus across a narrow canal from an amusement park. He had another decade to live – and more losses to grieve over – but this was one of the very last times the greatest printmaker in history was to use a burin and etching needle. Perhaps the technique required too much paraphernalia for his present circumstances? Perhaps it was too painstaking, too slow, too flat?

Whatever the reasons, they seem to be contradicted by the virtuosity and sensuality of the print produced [ill. 43]. The pretext was no longer a biblical story, but a vignette from Greek mythology, which may explain its greater freedom. Jupiter, wearing a crown of leaves and looking like a wrinkled satyr, has pulled back the sheet

43. *Jupiter and Antiope*, 1659. Etching (B. 203. I). Amsterdam, Rijksmuseum.

covering the young, splendidly naked Antiope.[29] He is leaning for-
ward out of the refulgence of his divinity into the brightness wash-
ing over her body. In a moment he will crawl onto the bed and take
her by force, but now he is simply feasting his eyes on her, and spe-
cifically on the shadowy triangle of her pubic patch. What is fated to
happen has not yet happened. Antiope, Rembrandt's lushest nude,
sleeps on unsuspecting, the inside of her left arm abandoned against
her disheveled hair, her right arm sinking into the downy softness of

29. This is, in fact, the second of the artist's renditions of Jupiter approaching the sleeping daughter
of King Nycteus. An etching of 1631 shows Antiope slumbering somewhat awkwardly on her left
side, her right hand draped decorously over her pubis and the other hand dangling over the edge of
the bed, as a hirsute, entirely naked Jupiter looms menacingly in the background. Her lumpy body
and bloated face bring to mind a large, pale fish.

a pillow, her breasts lifted to the light, her features utterly relaxed, the breath easily sliding in and out of her slightly parted lips. She is at once completely innocent and totally revealed. Her head is tilted back so that her nostrils are offered to our gaze. And though they are as warm and alive as any physical detail in Rembrandt's work, their elongated oval shape and fleshiness remind us of another pair of Rembrandt nostrils: those belonging to the wax-like nose of the "Kid" in the *Anatomy Lesson of Dr. Tulp* [ill. 28]. There is, in fact, a certain similarity between the two compositions: Jupiter crouches in much the same position as the surgeon depicted more than a quarter of a century earlier, and his left fist gripping the edge of Antiope's sheet parodies the elegant gesture of Tulp revealing the mystery of how the hand works.

The cadaver and the sleeping girl. They are both objects of lust, after all—the lust for knowledge and the lust for knowledge in the biblical sense. The lust to understand and the lust to possess—or, in both cases, simply the lust to see, to draw, to paint. Like Picasso in his countless variations on the theme of the old satyr and the beautiful young woman, Rembrandt has given us a mythological equivalent of the relationship between the artist and the model or, to put it in more general terms, between the artist and the world.[30]

---

30. Picasso explores this theme, mostly in a burlesque mode, in the series of drawings he produced in late 1953 and early 1954, published in the September 1954 issue of Emmanuel Tériade's art review *Verve*. Like Rembrandt, he plays with the shape of the nose of his figures, though unlike the Dutch master he prefers to sketch them in profile, either to emphasize the Grecian perfection of the woman posing or to lambaste the stupidity of the artist laboring myopically over his canvas to the point of being blind to the beauty in front of his eyes.

# 11

## The Highlight on the Tip of the Nose

So it is not altogether surprising that in the final years of his life Rembrandt depicted himself at least three times in front of his easel in workaday dress, simply as an artist pursuing his trade. These self-portraits are so different in mood and technique from the dandified depictions of himself posturing in velvet with a gold chain draped over his shoulders that one might take them for the work of a rougher artist, one who had lost any illusions he might have had about himself and his fellow human beings. The paint is laid down with stormy brushstrokes that give the overall picture the blustery quality of a beach during an autumn equinox. The pigment is charged with darkness shot through with flashes of shifting, lurid light, with brown and soiled ivory tones, expiring gold and hectic reds whipped onto the canvas from every angle at once. One has the impression that the painter has attained

a furious ubiquity – that after forty-odd years of wielding brush and paint he has gained a guerrilla chief's ability to surround the picture surface and attack it simultaneously from all sides. Rembrandt's late paintings have the sudden violence of an ambush.

You might think that this would give his self-depictions a martial look. But no, there he stands in front of us garbed in an old cloak, gripping his palette and brushes in his left hand as if for support, his gray hair, wiry and unkempt, escaping from a plain white bonnet of the kind a miller's apprentice might wear – unless it's simply a rag he's wrapped around his head to keep his hair out of his eyes. There's nothing triumphant about his expression. He's no conqueror; he's not showing off; there is no rich and wonderful booty draped over his shoulders or gleaming in the background. There is only the pervasive darkness, the faint luminous streak of the edge of the canvas he's working on, the banked embers of the colors on his palette, and the light on his features. He is not pulling a face as he did in his youth, or peering out from behind an actor's mask. His visage is old, wrinkled, pouchy. He's playing his last role, the role he'll be known for in history: Rembrandt the survivor of his own folly.[31]

---

31. Though Rembrandt could not know this at the time, two of the self-portraits of this final period were soon to enter royal collections (like his *Self-Portrait with Soft Hat and Gold Chain* of c. 1630, which Constantijn Huygens had presented to England's King Charles I some thirty years earlier and now hangs in the Walker Gallery in Liverpool). A dozen years or less after the artist's death the *Self-Portrait* of 1660 would hang in a gallery of Louis XIV's palace at Versailles and in due course it would be transferred to the Louvre, to become the first of that museum's collection of fifteen genuine Rembrandts. The half-length *Self-Portrait* of 1652 now hanging in the Kunsthistorisches Museum in Vienna made its way early in the next century into the collection of the Habsburg emperor Charles VI. So while the late Rembrandt was slipping from fashion in his own country, he was on his way to being perceived in the rest of Europe as one of the supreme masters of Western painting.

It was in the years immediately following his death that most of the anecdotes about Rembrandt's churlishness, his painting and teaching methods, were collected and published. Rembrandt's student

A contemporary of Rembrandt, the painter Abraham Breughel (a late member of the famous Flemish family of artists), remarked somewhat tartly a few years later that while Rembrandt was assuredly a master of half-length portraits, nevertheless "great painters do not like to spend their time on such bagatelles as draped half-lengths with only the tip of the nose illuminated, the rest being left so dark that one cannot identify the source of light. . . ."[32] Apparently Breughel preferred the more polished style of Rembrandt's by then more fashionable and successful student, Govert Flinck. He did not see that, far from being the mark of the kind of "inexpert painters who try to hide their models with obscure and cumbersome garments," Rembrandt's practice of wrapping his sitters in shadowy drapery and darkness was intended to isolate and give prominence to the light playing on their faces. This is the real focus of his portraits and self-portraits. Similarly, the highlight on the tip of the nose signposts the way to a proper perception of the painting as a whole—it tells us to concentrate our attention on the area around it—and at the same time it is like a condensation, a drop, of radiance, without which there would be no life, no visible likeness. The composition is structured and given meaning by the contrast and all the intervening shades and halftones between a congeries of darkness and a pinpoint of light in the middle of the sitter's face.

Samuel van Hoogstraten, who entered the master's studio at the age of fourteen, reflected on his experiences there in a treatise on the making of art issued in Rotterdam in 1678. And Hoogstraten's pupil Arnold Houbraken consigned many of the stories concerning Rembrandt, which he had heard from *his* teacher's lips, to his three-volume history of Dutch painting, published in Amsterdam in 1718.

32. Quoted in Schwartz, op. cit., p. 308.

Of course, this is a formula of portrait painting and Rembrandt is by no means the only seventeenth-century Dutch master to use it, although he, more than any other artist, established it as a basic device of portraiture for centuries to come. His greatness lies in the way he worked it in scores of portraits and self-portraits, which are everything but formulaic. In the Louvre's *Self-Portrait* of 1660 [ill. 44], for example, our eye is captured initially by the broad and energetic streaks of lead-white pigment that provide a summary description of the cap. They are the most luminous, individually visible brush-strokes in the composition. But then our gaze, as though primed with this brightness, begins to seek out other luminous patches. It takes in the forehead and temple on the left side of the face, the filament of silver hair glowing above the ear, the catchlights on the lids of the sitter's right eye and on the corrugations beneath it. The intensity of these quick, sharp strokes and scribbles and dabs of white, or near white, pigment decreases as we travel down the diagonal formed by the right shoulder, the lapel of the artist's coat, and the maulstick in his shadowy right hand. It revives briefly in the lumps of white, ochre, and red pigment – a virtual decomposition of the hues used to tinge the face – puddling the palette. But it's on the globule of pure white slightly to one side of the tip of the nose that, after being pulled down to the bottom right corner of the composition and then up again along the edge of the canvas the artist is working on, our gaze comes to rest.

However, this is a precarious resting point. The fact that it is located on the vertical axis running from the tip of the chin to the point where the sitter right's eyebrow begins above the ridge of the

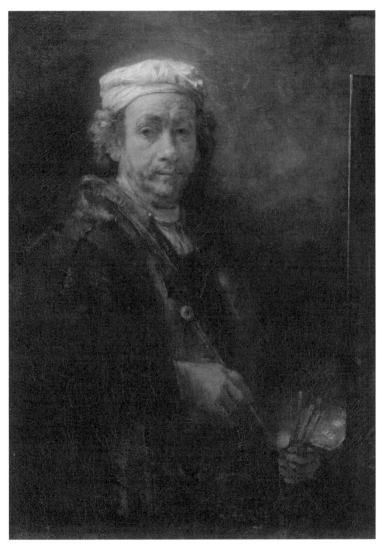

44. *Self-Portrait*, 1660. Oil on canvas, 43¾ × 33½ inches. Paris, Musée du Louvre.

nose gives it a certain harmony in the map of the face. It is well placed, one feels. Yet as the face is turned slightly to one side there is also something skewed about it. Three-fifths of the face lies to the left of the highlight on the nose, while the nose itself, wide, somewhat flattened, and possessing just a hint of the bulbousness made famous by Rembrandt's last self-portraits, thrusts into the shadowy halftones of the remaining two-fifths. It's as though the nose had a will of its own and was rebelling against the ideal of symmetry. (All of Rembrandt's faces resist symmetry.) The device itself is not particular to Rembrandt, but what is characteristic is the strongly textured treatment of the angled nose, the dark-to-light layers of transparent and opaque pigment building up a fusion of blemished skin and palpable light. The highlight on the tip of the nose – the most prominent point on both the face and the surface of the canvas – is the painting's finishing touch, even if it is not literally the artist's last brushstroke: it's the cherry on the sundae, the rain drop on the leaf, the beauty spot on the edge of a smile. It has thickness, density. It literally stands out on the surface of the picture – hence the joke about one being able to pick up a Rembrandt portrait by the nose. Yet it never ceases to be what it was meant to be: a tiny gleam of reflected light. Painting has never come this close to what it portrays.

And so the artist's face, leaner and frailer than it has ever been, and more melancholy (there is something of Bathsheba's wondering sorrow in his arched eyebrows), gazes out at us from a welter of pigment. There is still a balance between the claims of his likeness – this is me, Rembrandt – and the claims of the material: this is a painting, and even, this *is* painting. But in the eight or nine years following

the Louvre *Self-Portrait*, as first Hendrickje and then Titus died and Rembrandt's life grew increasingly somber, his painting came to look as if it had been troweled onto the canvas, and the sheer physical presence of pigment in a thick impasto overwhelmed everything else. The artist's likeness and that of his sitters became encased in paint. He had undergone many changes in his career: shock-haired young rebel, swaggering prince of painters, upwardly mobile bourgeois, Italianate courtier, defiant bankrupt, survivor. And now he was undergoing his final metamorphosis. Like Ovid's Myrrha whom the gods turned into a tree after she slept with her father, he became coffined in a gnarling crust of paint.[33]

In the Kenwood House *Self-Portrait* [ill. 45], painted some five years later, the artist is again wearing his white cap, but now the broad technique of the cap in the Louvre painting extends to every part of the composition, including the face. Some areas are extremely sketchy, such as the hand holding the palette; others are more elaborately worked – for example, the warm russet and plum reds of his clothes, brushed in a thin glaze over black; and still others, like the half-circles on the wall or wall-hanging in the background, and the not-quite vertical line on the upper right side, confer a geometric stateliness to the

33. "... And already
    The gnarling crust had coffined her swollen womb.
    It swarms over her breasts. It warps upwards / Reaching for her eyes as she bows /
        Eagerly into it, hurrying the burial
    Of her face and her hair under thick-webbed bark. / Now all her feeling has gone
        into wood, with her body. / Yet she weeps. . . ."
(Ted Hughes, *Tales from Ovid*, London: Faber and Faber, 1997, p. 128.)

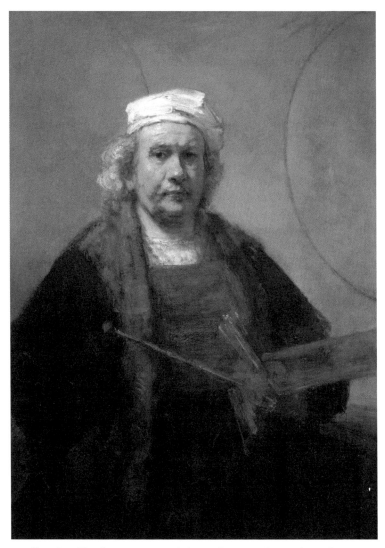

45. *Self-Portrait*, c. 1665. Oil on canvas, 45 × 37½ inches. London, Kenwood House, The Iveagh Bequest.

composition that is like nothing Rembrandt has ever painted before.[34]
If the painting is unfinished, it is hard to imagine what finishing could
add to it. Look at the face; look at the nose. Pigment slapped onto pig-
ment as roughly as if this were masonry. The familiar highlight on the
side of the nose is right where you would expect, but it looks like it
has been pasted on, and immediately next to it is a pink patch partly
covered by a couple of smoky black streaks. More black streaks overlap
on the ridge of the nose. The texture of the skin tones is coarse, pitted,
scabby. And yet how extraordinarily deft and precise every stroke is,
from the faint pink on the edge of the nostril on the left to the trans-
lucent growth on the eyelid!

Physicians given to the hobby of interpreting genius periodically
conclude that Rembrandt suffered from this or that ailment, this or
that skin condition, this or that impairment of vision. They tell us
nothing about Rembrandt's art. For the matter with Rembrandt was,
precisely, matter: the roughness of his "broad" style in his fifties and
sixties reflected the worn skin he saw on his own face and on that of
his mostly elderly sitters – the sags and swells, irritations and erup-
tions, creases and wrinkles, crow's-feet and pouches. Having painted
in his youth and middle years the costliest textures – velvet, sable,
silk, the finest linen and lacework, rich embroidery, gemstones and
pearls, polished steel and smoldering gold – he put these riches aside
and in his last decade labored obsessively to recreate the rugosity of

34.  While it seems fairly clear that the upright line (actually two lines) in the right corner repre-
sents the edge of the painting the artist is working on, the significance of the two hemispheres
remains a puzzle. Much ingenuity has been expended on trying to interpret them. The simplest
explanation is that they are a schematic rendering of a map of the world of the kind that hung in
many seventeenth-century Dutch interiors.

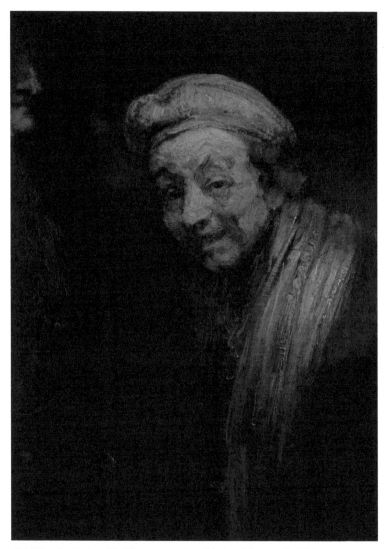

46. *Self-Portrait as Zeuxis*, c. 1669. Oil on canvas, 32½ × 25⅝ inches. Cologne, Wallraf-Richartz-Museum.

aging skin in layered pigment. There is no more common fabric than skin; the beggar and the burgomaster are clothed – and unclothed – in it. Jean Genet wrote that Rembrandt ended by transferring the éclat of precious materials to the lowliest matter. "Each of his faces is as good as another . . . and brings us back – or leads us – to a human identity as good as another. Every object has its own splendor, neither greater nor less than that of any other object."[35]

In his two last appearances as an artist, both painted in the dark year 1668–69 when his only surviving son Titus was carried off by the plague – Titus, whose feminine eyes and long straight nose, so different from the root-vegetable protrusion on the artist's face, he had portrayed repeatedly and lovingly – Rembrandt depicts himself peering out at the vanity of human striving. The first of these self-portraits, in the Wallraf-Richartz-Museum in Cologne, is clearly a *tronie* of a cackling old man stooping in front of a grotesque profile [ill. 46]. It is difficult to interpret, as it has probably been cropped from a larger painting. One school of thought casts the old man as the Greek painter Zeuxis, who is said to have died in a fit of laughter while painting a wrinkled old woman; the other sees him as the "laughing philosopher" Democritus, unable to restrain his mirth at the spectacle of human life.[36] Ultimately, of course, the script is irrelevant and what

35. "*. . . .chaque visage se vaut . . . et renvoie – ou conduit – à une identité humaine qui en vaut une autre. Chaque objet possède sa propre magnificence, ni plus ni moins grande que celle de tout autre. . . .*" (Jean Genet, *Rembrandt* ["Le Secret de Rembrandt" suivi de "Ce qui est resté d'un Rembrtandt déchiré en petits carrés bien réguliers, et foutu aux chiottes"], Paris: Gallimard, 1995, p. 31.)

36. Gary Schwartz favors the Zeuxis theory developed by Albert Blankett ("Rembrandt, Zeuxis and Ideal Beauty," in *Album Amicorum J. G. van Gelder*, The Hague, 1973). Simon Schama leans toward Democritus on the grounds that the bust on the left makes a rather implausible "old woman." That Rembrandt should have chosen to depict himself as an artist laughing at an ugly face seems out of

we get is what we see: a pair of figures, one of them insolently alive, the other perhaps an effigy—a crouching old man and a tall, shadowy profile—immersed in darkness where they are picked out by the uncertain gleam of a smoky candle or lantern. The light, tinged and as if filtered by a thick layer of shellac, glows on a turmoil of heavily laden brushstrokes. If you stand very close to the surface of the painting you feel you are looking at bubbling volcanic magma. When you step back, the fiery mass of pigment resolves itself into a cap (perhaps the one we saw in the two previous self-portraits) like a flat lump of dough, a flowing scarf, and a face hastily thrown together around a very large, sharpish, protruding nose. The joke of the painting is that a massive nose dominates the faces of both figures—the painter and his model, patron, inspiration, or target. They're a pair, two clowns in the same farce.

There is not even the shadow of a smile in the second *Self-Portrait*, now in the National Gallery in London, which depicts the artist both in terms of what he cannot get rid of and what he has relinquished [ill. 47]. The pose recalls that of the Titianesque *Self-Portrait at the Age of Thirty-Four*, also at the National Gallery, painted when the artist was at the peak of his career: before Saskia died, before his financial troubles and the scandals. But instead of inky, velvet-slashed sleeves and a gold chain looping over the rich nap of an ample beret, he is

character and a contradiction of his lifelong fascination with battered physiognomies. On the other hand, there is a certain appeal to the idea of Rembrandt taking his last (or next to last) bow as the founder of Greek atomic theory, which holds that everything consists of infinitesimal particles, differentiated only by shape and size, moving randomly in a limitless void. Still, judging from the paucity of books listed in the inventory of his belongings drawn up for the insolvency court, Rembrandt was not much of a reader. The possibility that he came across Democritus' treatise *On Cheerfulness* during his school days seems pretty slim.

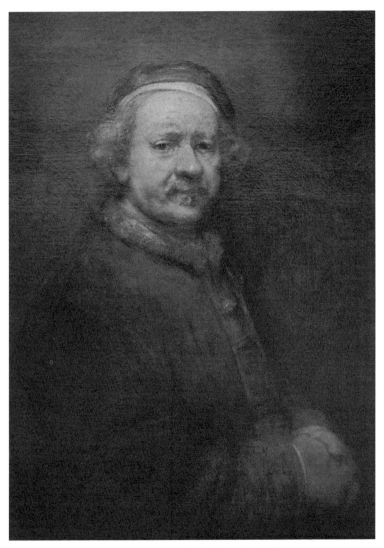

47. *Self-Portrait*, 1669. Oil on canvas, 33⅞ × 27¾ inches. London, National Gallery.

garbed in a tight-fitting cap and a coat of the homeliest plainness. Except for the edge of the old artist's fetish headgear peeping out under his calotte, we would not know that the man presenting himself to us in such an unassuming, workaday guise is a master painter, or even a painter at all. (An X-ray analysis of the self-portrait reveals that Rembrandt had initially portrayed himself holding a palette and brushes before deciding to depict his hands clasping each other in a prayer-like gesture – or perhaps simply the gesture of a man trying to keep his fingers warm.)[37] For all we know, he could be an elderly shopkeeper or – why not? – retired miller. The great Rembrandt has gone back to, or perhaps finally come to accept, the homespun garb of the hardworking people he was born among. Perhaps he is remembering the sighing of the reeds growing in the wetlands at the foot of the city walls in front of his childhood home in Leiden, the whispering of spring winds captured by the watery syllables of his family name – van Rijn, of the Rhine – the name with which he had not signed a single work in almost forty years.

The color of the sitter's attire blends in so completely with the muddy shadows and the earth tones of the shallow background that it is impossible to distinguish them clearly from each other. Everything is brown, the brown of a freshly ploughed field under an October drizzle. The composition is both literally and figuratively a brown study. Only the artist's face appears distinctly, and even it is tinged with terracotta hues that suggest a kind of primal matter quickened

37. The X-ray is reproduced in the National Gallery exhibition catalogue edited by Christopher Brown, Jan Kelch, and Pieter van Thiel, *Rembrandt: The Master and His Workshop*, New Haven and London: Yale University Press, 1991, p. 290.

with light. The eyes are small, dark, and impenetrable in their nest of raw, drooping skin. They have seen everything; they expect nothing; they gaze steadily at the vanity of the world. Perhaps they make us a little uncomfortable. At any rate, it isn't so much the look in the eyes we recall; it's that bulging, bloated nose with the lighthouse gleam on its tip. How can we forget it? It thrusts out at us from the middle of the face, forever calling attention to itself and to the paint from which it is shaped.

To Collegiate Assessor Kovalyov, losing one's nose was like losing one's rank and position in life. Rembrandt suffered the opposite fate: in a sense, he lost everything but his nose.

# 12

## An Old Man's Rasping Exhalations,
## an Infant's Purling Breath

Rembrandt died on the 4th of October 1669 and was buried four days later without much ceremony in a rented grave next to that of Hendrickje Stoffels in Amsterdam's Westerkerk. Before his body was laid to rest a notary came to his home, a certain Steeman, and drew up an inventory of his personal effects. There was not much to list, just a few household things: four plain wooden chairs, a few dishes and candlesticks, a couple of pairs of green lace curtains. And of course there was his painting paraphernalia: his easel, his caked palettes and brushes, jars of pigment, a bottle or two of linseed or walnut oil, a stone for grinding colors. Scattered about were more valuable items, bits of armor, "rarities and antiquities," a large number of drawings and prints, and thirteen paintings which in the notary's opinion were "unfinished." These being now considered the property of the artist's

only direct legal heir, Titus' daughter, the barely six-month-old Titia van Rijn, the notary locked the door of Rembrandt's studio and two other back rooms of the house where he had spent his last years, and placed his seal on them, protecting them from the rapacity of creditors and indelicate relatives.

Two of the paintings from this hoard depict a son being clasped in the arms of a bearded old man. After they were eventually released with the permission of Titia's guardian, an unknown hand, probably one of Rembrandt's former students, painted in extra figures to make them more marketable. So it takes a small effort of the imagination to picture these canvases as Rembrandt left them: two sizeable and rather murky rectangles of dark paint with a relatively small area illuminated by a strangely sourceless beam of light. In the remarkably intimate atmosphere thus created, the graybeard and the child occupy a position somewhat to the left of the central axis, as if the framing of each of the two scenes was slightly skewed. Both works exemplify the "broad" or "rough" style of Rembrandt's final years, and in the smaller, later painting (assuming it really is the composition the painter Allaerd van Everdingen noticed in the master's studio when he visited him a couple of weeks before his death), the paint has a particularly granular look. One might think it had been drizzled onto the canvas, driven against it by a gale.

The subjects of the two paintings are traditional, inspired by verses from the Gospel according to Luke which have spawned countless works of Dutch art. Rembrandt had tackled them before and they obviously held a special meaning for him. The larger canvas, now in the Hermitage in St. Petersburg, is a depiction of the crucial scene

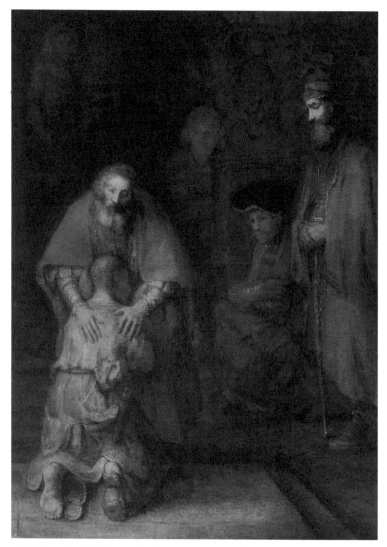

48. *The Return of the Prodigal Son*, c. 1662. Oil on canvas, 103⅛ × 81⅛ inches. St. Petersburg, The Hermitage.

in the parable of the Prodigal Son [ill. 48]. Some thirty years earlier Rembrandt had made an etching of the father embracing his emaciated, hirsute son on the steps of his house. And he had depicted himself in oils as a fashionable rake with a less-than-enthusiastic courtesan (perhaps modeled by his wife Saskia) on his knees, raising an astonishingly tall wine glass in a toast to the vanities of youth, sexual love, and free spending. But here the Prodigal Son is in rags and his hair is shorn like the scalp of someone suffering from an infestation of lice. Having squandered his inheritance and known the pangs of hunger and ostracism, he is kneeling in penitence, abandoning himself to the loving touch of his father who, moved by compassion, has rushed forth to take him in his arms. The title *The Return of the Prodigal Son* is in fact a little misleading, for the whole point of the composition is the forgiving, unconditional love of the father attired in a magnificent red cloak. The parable it is based on is, after all, about God's acceptance of those who rebel and return. "For this my son was dead," speaks the father clasping his boy; "he was lost and is found."[38]

The features of both father and son are curiously indistinct, far less detailed than the veined, wrinkled back of the old man's hands and the equally wrinkled sole of the youth's prematurely aged left foot. And while it is impossible to ignore the father's sketchy, half-shut eyes and dart-like nose, it is easy to miss the details of the son's dark and dusty visage, easy not to notice *his* nose: it is feminine, dainty, and trim, with delicately exposed nostrils, altogether different from the nose of Rembrandt's usual outcasts (remember the beggars of his

38. Luke 15:24.

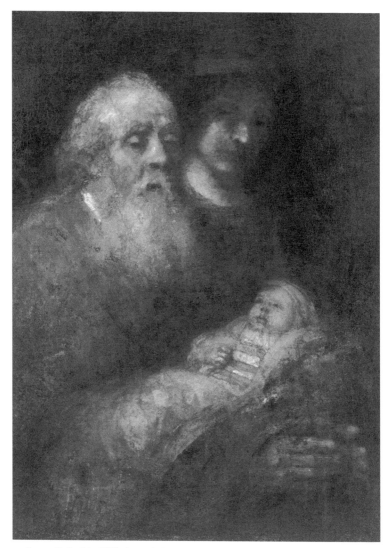

49. *Simeon with the Christ Child in the Temple*, begun in 1661. Oil on canvas, 38⅝ × 31⅛ inches. Stockholm, Nationalmuseum.

early years). One almost has the feeling that it has been transformed
by the father's touch. (In the etching of 1636, the son's nose is gross
and flat—a pig's snout.)

The second canvas is also a repeat [ill. 49]. It's a deeply felt and
much pared-down restatement of one of Rembrandt's earliest oils,
painted when he was still a youth in Leiden. It depicts the very old,
very devout Simeon cradling the infant Christ in his huge, gnarled
hands. The composition as it now stands includes a third figure, the
Virgin, gazing down at her swaddled baby from the background, but
in Rembrandt's painting, as it was originally, there was only a very old
man and a very small child.

Simeon's eyes are narrow slits and seem blind, emphasizing the
fact that what he is beholding is no mere terrestrial sight but a vision
of salvation. For the Gospel tells us that Simeon had a revelation that
he would not see death until he had beheld the Messiah and the Holy
Spirit led him to the temple, and now he is standing within its precinct
clasping Mary's child. And though his eyes are shut his mouth is ajar
and his nostrils are wide open, as if he were inhaling the infant's pres-
ence. His nose is the opposite of the child's: boney and pronounced,
with a faint bump on the ridge. We've seen it before, in portraits of
Rembrandt's father, but it's no longer dour and lowered as if to shut
out or fend off life. It's raised and as receptive as the child's. It's a nose
seen from below, as a baby would know it.

So Rembrandt's last painting is not about sight but about accep-
tance. The old man's breaths are counted, but he can now depart in
peace, and the child, having just started to breathe through the tiny,
pink openings of his as yet unformed nose, can take his place in the

world. Even in a glossy reproduction, the image, blending the deepest and the gentlest tones of Rembrandt's last manner – ruddy ochres, coal blacks, ember red, gauzy ivory – radiates an atmosphere of utter peacefulness and tenderness. It is so intimate, so still, that one can hear the old man's rasping exhalations and the infant's purling breath in the hushed temple.

We will doubtless never know the identity of the old man who sat for the figure of Simeon, but surely the baby who modeled the infant Jesus was tiny Titia. Rembrandt would have known the weight of his godchild and only granddaughter; he would have marveled at her eyelashes and fingernails and breathed in the smell of her wondrous skin.

# Chronology

Dates followed by an asterisk are uncertain or approximate. Works followed by § are discussed in the text. Only Rembrandt's major oils and etchings are listed. Unless otherwise noted, all works are oils and all etchings are from the Rijksmuseum in Amsterdam.

Currency: 1 guilder was roughly the wage for a weaver's twelve-hour day in Rembrandt's native Leiden. Qualified workers such as ship carpenters were paid about 10 guilders a week. A tradesman or shopkeeper's annual income came to around 1,000 guilders. A painting by a recognized artist sold for a few guilders on the open market. Rembrandt's early works sold for anywhere between 6 and 30 guilders in Leiden, where it was said was that "he was going to develop into an outstanding painter." Commissions brought in more, especially if they were commissions from the Stadholder's court at The Hague (for each of the five canvases of the *Passion* series Rembrandt, who complained that his fee ought be double this sum, was awarded 600 guilders). By way of comparison, in 1696, twenty-one years after Vermeer's death, the *View of Delft* was knocked down at a public sale for 72 guilders.

**1568–1648**

Eighty Years War between Spain and the Netherlands.

**1573–74**

Leiden besieged by Spanish troops. In an attempt to starve out the city's population, the Spaniards burn flourmills in the surrounding country, including one belonging to Rembrandt's paternal grandfather. Leiden's town council authorizes Rembrandt's grandmother to reerect the family mill on the city walls. The siege is lifted in October 1574, after almost a quarter of Leiden's population dies from illness and starvation.

**1606**

Rembrandt is born in Leiden on July 15 (a little over five months before the first performance of Shakespeare's *King Lear* on a London stage). He is the ninth child of Harman Gerritszoon van Rijn, a prosperous fourth-generation malt miller converted to Calvinism, and Cornelia Willemsdochter van Zuytbroeck, from a family of Catholic bakers.

Leiden, a bastion of the Reformed Church since its conversion to Protestantism in 1578, numbered some 12,000 inhabitants at the end of the sixteenth century and approximately 45,000 in the 1620s, making it the second largest city in Holland. Its economy is based on textiles, principally wool and linen.

The van Rijn's house and mill stands within the city walls on Weddesteeg, overlooking a branch of the Rhine (hence the family's name). The occupants include the artist's grandmother Lysbeth and her second husband, Rembrandt's mother and father, his four brothers and two sisters, a maidservant, two mill hands, plus a lodger.

Two van Rijn children die in infancy in 1604 and another dies in childhood in 1609. Of the surviving siblings, Rembrandt's oldest brother Gerrit will succeed his father at the family mill around 1621. His next brother, Adriaen, will become a shoemaker first, then will follow his father's trade after marrying a miller's daughter. A third brother, Willem, will become a baker. The other children are a brother named Cornelis, and two sisters, Machtelt and Lysbeth.

**1609–21**

Twelve Years Truce between Spain and the Netherlands.

**1620**

On May 16, Rembrandt is listed on the register of Leiden University as "Rembrandus Hermanni Leydensis, *studiosus Litterarum*," aged fourteen and still living with his parents. Between the ages of roughly seven and thirteen he attends a Latin school, where he is drilled in the Scriptures (the school's motto is "*Pietati, Linguis et Artibus Liberales*"), Virgil, Horace, Plutarch, and Tacitus, and gets

a smattering of Homer, Euripides, and Hesiod. He is taught calligraphy and takes drawing lessons from a certain Henricus Rievelink.

The years of his childhood and adolescence are marked by bitter disputes centering on the university, between adherents of a tolerant Calvinism, the so-called "Remonstrants," and the hardline "Counter-Remonstrants," who want to rid the brand-new Dutch Republic of Catholics, Jews, and Remonstrants. The conflict comes to a head in 1618, when the Stadholder Maurice mobilizes the army on the side of the Counter-Remonstrants. In 1619, Johan van Oldenbarneveldt, a hero of the 1574 Leiden siege, one of the founding fathers of the Dutch republic, and a leading figure in the Remonstrant party, is summarily tried for treason and executed. Leiden University's most illustrious alumnus, the jurist Hugo Grotius, is sentenced to life imprisonment.

Rembrandt's name does not appear in any of the University's records after May 16. The local historian Jan Orler will later relate from hearsay that "he had no desire or inclination" for university studies, and that "his only natural inclination was for painting and drawing, so that his parents were compelled to take their son out of the School and . . . apprentice him with a Painter. . . ."

### 1621–23

Rembrandt is apprenticed to Jacob Isaacszoon van Swanenburgh at Leiden, a painter who had visited Italy and had probably spent time in the studio of Jacob Pynas, an artist strongly influenced by Adam Elsheimer.

### 1624

Around this time Rembrandt travels to Amsterdam and works for roughly six months in the studio of Pieter Lastman (1583–1633), renowned as a master of historical scenes. This artist marks his first surviving oil paintings. Rembrandt then returns to Leiden and works briefly under Joris van Schooten before setting up his own studio in his family home on Weddesteeg.

### 1625

By 1625 Rembrandt is working as an independent master in Leiden. Beginning of his association with another of Lastman's students, his fellow Leiden painter, Jan Lievens (1607–74).

Rembrandt's first-known dated work *The Stoning of St. Stephen* (Lyon, Musée des Beaux-Arts).

### 1626

While perhaps sharing a studio in Leiden with Jan Lievens, Rembrandt paints historical and biblical scenes after the manner of Pieter Lastman: *Tobit and Anna with the Kid* § (Amsterdam, Rijksmuseum); *Balaam and the Ass* (Paris, Petit Palais);

*The Baptism of the Eunuch* (Utrecht, Catherijneconvent); *Christ Driving the Money Changers from the Temple* (Moscow, Pushkin Museum); and *The Magnanimity of Claudius Civilis* (Leiden, Stedelijk Museum).

- *Self-Portrait*★ (Cassel, Gemäldegalerie)
- *Musical Company* (Amsterdam, Rijksmuseum)
- *Seated Old Man* § (drawing, Paris, Musée du Louvre)

Rembrandt takes up etching.

### 1627

*St Paul in Prison*
Stuttgart, Staatsgalerie.

### 1628

Gerrit Dou (1613–75), Rembrandt's earliest pupil, enters his studio on February 14. Around this time Rembrandt meets the Utrecht connoisseur Arnout van Buchell, who writes in his *Res pictoriae:* "The son of the miller from Leiden is highly esteemed, but before his time."

Rembrandt's first studies of beggars.

- *Two Old Men Disputing*★ (Melbourne, National Gallery of Victoria)
- *Samson and Delilah* (Berlin, Gemäldegalerie)
- *The Supper at Emmaus* § (Paris, Musée Jacquemart-André)
- *Self-Portrait* (Amsterdam, Rijksmuseum)

### 1629

Constantijn Huygens, secretary to the Stadholder Frederik Hendrik, visits Rembrandt and Lievens in Leiden. Lievens paints Huygens's portrait and, around the same time, a portrait of Rembrandt.

- *Portrait of the Artist Aged About 23* (The Hague, Mauritshuis)
- *Self-Portrait in a Gorget* § (Nuremberg, Germanisches Nationalmuseum)
- *The Artist in His Studio* (Boston, Museum of Fine Arts)
- *Self-Portrait* § (Munich, Alte Pinakothek)
- *An Old Woman at Prayer* (*"Rembrandt's Mother"*)★ (Salzburg, Salzburger Landessammlungen Residenzgalerie)
- *Repentant Judas Returning the Pieces of Silver* (private collection)

### 1630

Rembrandt's father dies and is buried in Leiden on April 27.

Constantijn Huygens writes in his autobiography around this time that "Rembrandt is superior to Lievens in his sure touch and in the liveliness of emotion; Lievens surpasses him in the loftiness of his concepts and the boldness of his subjects and forms. From his youthful spirit, he does nothing that is not magnificent and grand. . . . Rembrandt, on the other hand, devotes all his loving care and con-

centration to small painting, achieving on a small scale a result that one would search for in vain in the largest works of others" (Simon Schama, op. cit., p. 259).

- *Self-Portrait with Soft Hat and Gold Chain*★ § (Liverpool, Walker Gallery)
- *The Resurrection of Lazarus*★ (Los Angeles County Museum of Art)
- *Jeremiah Lamenting the Destruction of Jerusalem* (Amsterdam, Rijksmuseum)
- *St. Paul at His Writing Desk*★ (Nuremberg, Germanisches Nationalmuseum)
- *The Artist's Father* § (red and black chalk drawing with brown wash, Oxford, Ashmolean Museum)
- *Bust of an Old Man in a Fur Cap ("Rembrandt's Father")*★ (Innsbruck, Tiroler Landesmuseum Ferdinandeum)

Rembrandt's first nude, the lumpish *Diana Bathing* (etching).

### 1631

Death of Rembrandt's older brother, Gerrit.

The Amsterdam art dealer Hendrick van Uylenburgh visits Leiden and perhaps buys work from Rembrandt. On June 20, Rembrandt lends 1,000 guilders to van Uylenburgh, probably as an investment in the latter's art business. Van Uylenburgh invites Rembrandt to come to Amsterdam and work for him.

Toward the end of the year, Rembrandt moves into a space at the back of the art dealer's house on Amsterdam's Sint-Anthoniebreestraat. A sharp decline in Rembrandt's production of etchings and history paintings, probably due to the fact that he is busy teaching and supervising van Uylenburgh's workshop and working on portrait commissions.

- *Portrait of Nicolaes Ruts* § (New York, The Frick Collection)
- *Young Man at His Desk* (St. Petersburg, The Hermitage)
- *The Artist in Oriental Costume, with Poodle* § (Paris, Petit Palais)
- *Old Man with Gorget and Black Cap*★ (Chicago, The Art Institute)

Rembrandt does a series of etched portraits of himself laughing, frowning, grimacing with his mouth open, looking terrified, with his hair standing up in a tangle or escaping in an unkempt profusion under various caps and soft hats. He also executes from memory a number of etchings of his father, looking patrician and solemn, plus three etchings of his mother (whose features also appear in the oil *An Old Woman Reading*, Amsterdam, Rijksmuseum).

Around this time, Lievens leaves Holland to seek success as a court painter in England.

- *St. Peter in Prison* (private collection)

### 1632

Rembrandt stops signing his works RHL (Rembrandt Harmensz. Leijdensis) and begins using his first name after the manner of the great Italian masters. Between November 1631 and December 1632 he paints about one portrait per month, mostly of prominent Amsterdam citizens and their wives, for fees ranging from 50 guilders for a bust to 500 guilders for a full-length, life-size work. Some time in 1632 – only months after establishing himself permanently in Amsterdam – Rembrandt receives his most prestigious portrait commission, *Portrait of Amalia van Solms* (Frederik Hendrik's wife). On January 31, 1632, he attends the second public anatomy lesson of Dr. Nicolaes Tulp. The group portrait of Dr. Tulp and his students (The Hague, Mauritshuis) is a triumphant reformulation of the well-established Dutch genre of the corporation portrait.

At some point during this year Rembrandt receives a commission through Constantijn Huygens to paint two large scenes from the Passion of Christ for Frederik Hendrik (*The Raising of the Cross* and *Descent from the Cross*).

- *Self-Portrait* (Glasgow, The Burrel Collection)
- *A Man in Oriental Dress* ("*The Noble Slav*") (New York, The Metropolitan Museum of Art)
- *Portrait of Marten Looten* § (Los Angeles County Museum of Art)
- *Portrait of Jacques de Gheyn III* (London, Dulwich Picture Gallery)
- *Portrait of a Young Woman Seated* § (Vienna, Akademie der Bildenden Künste)

### 1633

On June 5, Rembrandt proposes to Hendrick van Uylenburgh's cousin Saskia. She is twenty-one, pretty, a burgomaster's daughter, and reasonably well-off: a good catch for the upwardly mobile artist who is now playing the card of bourgeois respectability (the young artist, portrayed in his Sunday best in the Glasgow *Self-Portrait* painted half year earlier, describes himself in the *album amicorum* of a visiting German art-lover as "a pious character [who] values honor above possessions").

In February, Huygens writes several squibs in Latin on Rembrandt's *Portrait of Jacques de Gheyn III* ("Had de Gheyn's face happened to look like this / Then this would have been an excellent portrait of de Gheyn"). "It is clear that . . . that 'honeymoon' between Huygens and Rembrandt was over" (Gary Schwartz, op. cit., p. 96).

The first two scenes from the *Passion* series are shipped to the Stadholder's palace in The Hague. They are well received and Rembrandt is subsequently commissioned to paint three further Passion scenes (an *Ascension*, an *Entombment* and a *Resurrection*).

- *Saskia Laughing* (Dresden, Gemäldegalerie)
- *Oval Self-Portrait with Soft Hat and a Golden Chain* § (Paris, Musée du Louvre)
- *Double Portrait of the Shipbuilder Jan Rijksen and his Wife Griet Jans* (London, Buckingham Palace)
- *Portrait of a Man Rising from His Chair* (Cincinnati, Taft Museum) and its pendant *Portrait of a Woman with a Fan* (New York, The Metropolitan Museum of Art)
- *The Good Samaritan* § (etching)

### 1634

One of Rembrandt's most prolific years. He acquires citizenship in Amsterdam and joins the painters' guild of St. Luke. In late June he marries Saskia in Friesland. Shortly after the wedding he begins work on two three-quarter-length pictures of Saskia as Flora, the goddess of springtime abundance (*Flora*, 1634, St. Petersburg, The Hermitage; *Flora*, 1635, London, National Gallery).

He does several full-length paired portraits of Amsterdam citizens and their wives, including Marten Soolmans and Oopjen Coppitt (Paris, private collection) and the preacher Johannes Elison and Maria Bockenolle (Boston, Museum of Fine Arts).

- *Self-Portrait with a Soft Hat and a Fur Collar* § (Berlin, Staadliche Museen, Gemäldegalerie)

- *Diana Bathing with Her Nymphs, with the Stories of Actaeon and Callisto* (Anholt, Museum Wasserburg Anholt)
- *Portrait of Saskia van Uylenburgh* ("*Saskia in a Red Hat*") (Cassel, Gemäldegalerie)
- *An Eighty-Three-Year-Old Woman in a Small Ruff and a White Cap* § (London, National Gallery)
- *St. John the Baptist Preaching* ★ (Berlin, Gemäldegalerie)
- *The Holy Family* ★ (Munich, Alte Pinakothek)
- *Ecce Homo* (London, National Gallery)

### 1635

Rembrandt buys costly engravings and sculptures at an auction sale in late February. He now has so many pupils and assistants that he is obliged to rent a larger studio on the Bloemgracht. His student and subsequent rival Govert Flinck succeeds him as master of van Uylenburgh's workshop. Toward the end of the year the plague breaks out in Amsterdam, killing close to one-fifth of the city's population. Rembrandt and Saskia's first child, Robertus, is born on December 15.

- *Self-Portrait with Saskia* ("*The Prodigal Son with a Whore*") (Dresden, Gemäldegalerie)
- *Abraham's Sacrifice* (St. Petersburg, The Hermitage)

- *The Abduction of Ganymede* (Dresden, Gemäldegalerie)
- *Belshazzar's Feast*★ (London, National Gallery)

### 1636

Robertus dies and is buried on February 15. In the same month, Rembrandt reports to Constantijn Huygens about his progress on the three remaining paintings commissioned by Frederik Hendrik, informing him that the *Ascension of Christ* is finished and that the *Entombment* and the *Resurrection* are "easily more than half done." (The last two paintings will not, in fact, be completed until three years later.) In a second letter, written later this year, Rembrandt asks to be paid 200 Flemish pounds (the equivalent of 1,200 guilders) for each of the new works, twice the rate he has been paid for the first two. His request is turned down.

The artist and Saskia move to the Nieuwe Doelenstraat, "next door to the pensionary Boreel." He paints *The Blinding of Samson* § (Frankfurt, Städelsches Kunstinstitut).

- *The Standard Bearer* (Paris, private collection)
- *Danaë* (St. Petersburg, The Hermitage)
- *Susanna and the Elders* (The Hague, Royal Picture Gallery)
- *The Return of the Prodigal Son* (etching)

### 1637

Rembrandt and Saskia move again, this time to the Jewish quarter on Vlooienburg Island, next to a house called "the Sugar Bakery." On March 19, Rembrandt pays 600 guilders at an auction sale for an album of drawings by Lucas van Leyden. On October 8, he buys Rubens's *Hero and Leander* for 424 guilders (he will resell it in 1644 for 530 guilders).

- *The Angel Leaving Tobias and His Family* (Paris, Musée du Louvre)
- *Landscape with a Stone Bridge* (Amsterdam, Rijksmuseum)

### 1638

Rembrandt brings a libel suit against Saskia's relatives for spreading gossip that he is squandering her legacy by "flaunting and showing off." The complaint points out that "the plaintiff stated (and without boasting) that he and his wife were richly and superabundantly endowed (for which the Almighty can never be sufficiently thanked)."

Birth of Rembrandt and Saskia's first daughter, Cornelia, who is baptized on July 22. She dies three weeks later and is buried in the Zuiderkerk.

An inventory of the Amsterdam wood merchant Cornelis Aertsz mentions several copies of Rembrandt paintings, evidence that the artist's work is now widely in demand. Pressed for money, Rembrandt writes to Huygens in January

begging him to expedite the payment for the last two paintings in the *Passion* series completed a couple of weeks earlier.

- *Christ Appearing to Mary Magdalen* (London, Buckingham Palace)
- *The Wedding of Samson* (Dresden, Gemäldgalerie)
- *Adam and Eve* (etching)

**1639**

Rembrandt buys a townhouse on Sint-Anthoniebreestraat for the substantial sum of 13,000 guilders. On May 1, he and Saskia move into their new dwelling, the only item of real estate the artist will ever own.

Charging 100 guilders a year per pupil for his teaching, Rembrandt attracts students from all over the Lowlands, Germany, and Denmark.

The *Self-Portrait with Soft Hat and a Gold Chain* § is listed in the collection of King Charles I of England.

- *Portrait of a Man Holding a Hat*★ (Los Angeles, Armand Hammer Collection)
- *Portrait of a Man Standing* (Kassel, Staatliche Kunstsammlung)
- *Portrait of Maria Trip* § (Amsterdam, Rijksmuseum)
- *A Man in Oriental Costume* (*"King Uzziah Struck with Leprosy"*) (Chatsworth, Duke of Devonshire Collection)

- *Hunter with Dead Bittern* (Dresden, Gemäldegalerie)
- *Still Life with Two Dead Peacocks and a Girl*★ (Amsterdam, Rijksmuseum)
- *The Entombment of Christ* (Munich, Alte Pinakothek)
- *The Resurrection of Christ* (Munich, Alte Pinakothek)
- *Self-Portrait Leaning on a Stone Wall* (etching)

**1640**

A second daughter named Cornelia is born to Rembrandt and Saskia. She is baptized on July 29 and dies soon after.

Rembrandt's mother dies at 73 and is buried on September 14. Rembrandt inherits half the mortgage on the family mill worked by his brother Adriaen, valued at 3,565 guilders.

- *Self-Portrait at the Age of 34*★ (London, National Gallery)
- *Portrait of Herman Doomer* (New York, The Metropolitan Museum of Art)
- *The Holy Family* (Paris, Musée du Louvre)

**1641**

Birth of Rembrandt and Saskia's second son. On September 22, the infant is baptized Titus, after Saskia's sister Titia, who had died three months earlier.

Publication of the second edition of Johannes Orlers's *Description of the City of Leiden*, which includes a short biography

of Rembrandt based on information possibly supplied by the artist's mother and ending: "He has now become one of the most famous painters of the century."

Publication on October 18 of a glowing description of Rembrandt's *Marriage of Samson* by the painter Philip Angel.

Rembrandt works on *The Nightwatch*.

Paired portraits of Nicolaes van Bambeeck § (Brussels, Musée des Beaux-Arts) and his wife, Agatha Bas § (London, Buckingham Palace, Collection of Her Majesty Queen Elizabeth II).

- *Double Portrait of the Mennonite Preacher Cornelis Claesz. Anslo and His Wife Aeltje Gerritsdr. Schouten* (Berlin, Gemäldegalerie)
- *Saskia Holding a Flower* (Dresden, Gemäldegalerie)

**1642**

Saskia in the terminal stage of tuberculosis (*Saskia Sick, with White Headdress*, etching; Pierpont Morgan Library, New York). On June 5, the notary Pieter Barcman is summoned to Rembrandt's house to draw up Saskia's will. She bequeaths her entire personal estate to Titus, but appoints Rembrandt sole executor and guardian of their child, "confident that he will acquit himself very well in all good conscience." She grants her husband the usufruct of the estate until such time as he remarries or the baby comes of age. She dies nine days later at the age

of thirty and is buried on June 19 in the Oude Kerk, where her sister's husband is a preacher.

In the weeks following Saskia's death, Rembrandt engages Geertje Dircx, a bugler's widow from Edam, as a live-in nurse for Titus.

Rembrandt is commissioned to paint a group portrait (*The Night Watch*) of a company of the Amsterdam militia led by captain Frans Banning Cocq, for their assembly hall. His fee is 100 guilders for each of the junior officers and men, 1,600 guilders in all.

Andries de Graeff, one of Amsterdam's wealthiest and most influential patricians, commissions Rembrandt to paint his portrait, but refuses to pay the agreed sum of 500 guilders after it is finished. Perhaps as a result of this failure, Rembrandt will paint no further society portraits in the next decade.

- *The Nightwatch* (Amsterdam, Rijksmuseum)

**1643**

Jan Lievens returns from England and settles in Amsterdam.

Rembrandt begins work on "*The Hundred-Guilder Print*," perhaps his most admired etching in the seventeenth century.

*The Three Trees*, one of his first landscape etchings.

**1644**

- *Christ and the Woman Taken in Adultery* (London, National Gallery)

**1645**

- *Young Woman in a Bed* § (Edinburgh, National Gallery of Scotland)
- *Girl Leaning on a Windowsill*★ (London, Dulwich College Gallery)
- *The Holy Family* (St. Petersburg, The Hermitage)
- *Landscape with Man Sketching,*★ *The Omval, Farmhouses beside a Canal,*★ *Six's Bridge* (etchings)

**1646**

Delivers two more paintings to Frederik Hendrik, identical in size to the five *Passion* paintings, a *Nativity* and a *Circumcision of Christ.* He is paid double the fee for the earlier pictures.

- *The French Bed,* § *Posthumous Portrait of Jan Cornelius Sylvius, Portrait of Ephriam Bueno, Portrait of the Artist Jan Asselyn* (etchings)

**1647**

Frederik Hendrik dies on March 14 and is succeeded by his son Wilhelm II.

Rembrandt's personal fortune is appraised at 40,750 guilders.

The twenty-one-year-old Hendrickje Stoffels joins Rembrandt's household around this time as a maidservant.

- *Susanna and the Elders* (Berlin, Gemäldegalerie)

- *The Rest on the Flight to Egypt* (Dublin, National Gallery of Ireland)
- *Portrait of Jan Six Standing by a Window* (sketch and etching)

**1648**

Dutch independence is finally recognized in the treaty of Munster.

In January Geertje makes a will, bequeathing her clothing to her mother, her portrait by Rembrandt (lost or unidentified) and 100 guilders to the daughter of one Pieter Beets of Hoorn, and "all other property, movable and immovable" to the artist's son Titus.

- *Self-Portrait of the Artist Drawing by a Window* (etching)

**1649**

Rembrandt dismisses Geertje, undertaking on June 15 to pay her 160 guilders a year for the rest of her life and allowing her to keep some of his former wife Saskia's jewels, which he had given her. Shortly thereafter, Geertje threatens to sue for breach of promise, claiming that Rembrandt had told her he would marry her. On October 1, Hendrickje Stoffels appears before the notary Laurens Lamberto to testify that Geertje had accepted the June 15 agreement with her master. Three days later, Geertje reiterates her acceptance of the terms before witnesses, but changes her mind again one week later. On October 16, Rembrandt

is fined 3 guilders for refusing to appear before the commissioners of marital affairs to answer Geertje's charge that he has not honored his promise to marry her. On October 23 he finally answers the commission's summons and denies ever having proposed to Geertje. The commissioners nevertheless decide to increase the artist's annual maintenance payments to her to 200 guilders.

### 1650

Rembrandt contrives to get two witnesses, a certain Cornelia Jan, a butcher's wife, and Geertje's own brother Pieter, to swear before a notary that his former housekeeper and mistress is of unsound mind. Their deposition is reaffirmed before the burgomasters of Amsterdam in July. Some time thereafter (possibly 1651), Geertje is committed to a workhouse in Gouda.

### 1651

- *Kitchen Maid* (Stockholm, Nationalmuseum)

### 1652

The first Anglo-Dutch War (1652–54) causes a serious economic slump in Amsterdam.

The artist's brother Adriaen dies in Leiden.

- *Self-Portrait* (Vienna, Kunsthistorisches Museum)
- *Portrait of Nicolaes Bruyningh* (Kassel, Gemäldegalerie)

### 1653

Beginning of the succession of events that will lead to Rembrandt's bankruptcy. Christoffel Thijs, from whom he had bought the Sint-Anthoniebreestraat house, pressures him to pay the balance owed on the property (7,000 guilders plus another 1,470 guilders in interest and "costs"). On February 1, a notary presents Rembrandt with a summons to pay. The artist obtains a loan of 1,000 guilders interest-free from Jan Six and contracts an even larger (4,180-guilder) loan from a captain of the guard named Cornelis Witsen. He undertakes to repay both debts within the year, but fails to do so.

Disturbed by restoration work being carried on his neighbor's house during the first nine months of this year, Rembrandt produces only one oil (*Aristotle Contemplating the Bust of Homer*, New York, The Metropolitan Museum of Art).

- *The Three Crosses* (etching)

### 1654

One of Rembrandt's most prolific years (along with 1629 and 1636).

In February Diego d'Andrada, a Portuguese Jewish merchant, refuses to accept a portrait he commissioned on the grounds that it bears no resemblance to the sitter.

On June 25, Hendrickje (some five months pregnant) is summoned to appear before

the Calvinist Church council to answer reports that she is "living in whoredom with the painter Rembrandt." After receiving two further summons, she confesses three weeks later to the charge and is severely admonished and banned from attending Communion.

Rembrandt's most gifted pupil, Carel Fabritius, is killed in the explosion of the Delft arsenal on October 12. Shortly thereafter, Hendrickje gives birth to a daughter. On October 30 the infant is baptized Cornelia (the third baby to be named after the painter's mother) in the Oude Kerk, where Saskia and *her* two Cornelias are buried.

- *Bathsheba with King David's Letter* § (Paris, Musée du Louvre)
- *Flora*★ (New York, The Metropolitan Museum of Art)
- *Portrait of Jan Six* § (Amsterdam, Six Collection)
- *A Woman ("Hendrickje") Bathing* (London, National Gallery)
- *Portrait of Floris Soop* (New York, The Metropolitan Museum of Art)

### 1655

In May, Abraham Breughel reports to Don Antonio Ruffo of Messina that "the paintings of Rembrandt are not held in high esteem" in Holland.

Toward the end of the year, Rembrandt has Titus draw up a will leaving everything to him and nothing to his mother's family.

In December, Rembrandt auctions off part of his collection of curiosities and artworks but fails to pay off his debts.

- *Portrait of Hendrickje Stoffels*★ (Paris, Musée du Louvre)
- *The Slaughtered Ox* (Paris, Musée du Louvre)
- *Titus at His Desk* (Rotterdam, Boymans-van Beuningen Museum)
- *A Man in Armor* (Glasgow, City Art Gallery and Museum)
- *David Playing the Harp before Saul*★ (The Hague, Mauritshuis)

### 1656

In May, Rembrandt transfers the title of his house to Titus. On July 10, he appears before the Chamber of Insolvency Estates and applies for a *cessio bonorum* (insolvency). The court names a liquidator on July 20 and five days later a clerk comes to the artist's home and draws up an inventory of his belongings. He lists 363 items, including some 60 paintings by Rembrandt, several books of his drawings, and a large collection of sketches, etchings, and paintings by Dutch, Flemish, and Italian masters, as well as a vast assortment of antique statues, musical instruments, weapons, pieces of armor, minerals, shells, objets d'art, and a handful of books.

In August or September a sale of Rembrandt's household goods, excluding his collection and his own works, fetches little more than 1,300 guilders.

- *Woman at an Open Door ("Hendrickje Stoffels")* (Berlin, Gemäldegalerie)
- *Titus Reading*★ (Vienna, Kunsthistorisches Museum)
- *Jacob Blessing the Sons of Joseph*★ (Kassel, Schloss Wilhelmshöhe)
- *The Anatomy Lesson of Dr. Jan Deyman* (Amsterdam, Rijksmuseum)

**1657**

On August 1, Gerbrand Ornia, a rich patrician in the highest circles of Amsterdam's regency, recalls Rembrandt's debt to Jan Six (which he had acquired a year or two previously).

On November 21, Rembrandt's collection is auctioned off, fetching less than 3,000 guilders.

- *Self-Portrait* (Edinburgh, National Gallery of Scotland)
- *The Polish Rider*★ (New York, The Frick Collection)

**1658**

The Insolvency Court overrules the transfer of Rembrandt's house to Titus on February 2. The house then goes on the block and is acquired for 11,218 guilders (some 2,000 guilders less than what the artist had paid for it) by a shoemaker and seller of silk goods.

Rembrandt, Hendrickje, and Titus leave the house on the Sint-Anthoniebreestraat before May and move to more modest lodgings at the southern end of the Rozengracht, opposite an amusement park.

Rembrandt rents a studio from a maker of playing cards.

- *Portrait of Titus* (London, National Gallery)
- *Self-Portrait* (New York, The Frick Collection)
- *Jupiter and Mercury Visiting Philemon and Baucis* (Washington, D.C., National Gallery of Art)

**1659**

- *Moses Preaching the Tables* (Berlin, Gemäldegalerie)
- *Jacob Wrestling with the Angel* (Berlin, Gemäldegalerie)
- *Tobit and Anna Waiting for Their Son* (Rotterdam, Boymans-van Beuningen Museum)

**late 1650s–early 1660s**

Amsterdam's leading painters are commissioned to do a series of large history pictures for the new Town Hall. Rembrandt is passed up in favor of his former students Govert Flinck and Ferdinand Bol.

**1660**

On February 2, Flinck dies before completing *The Oath of Claudius Civilis* for the Town Hall. Rembrandt is asked to complete this monumental commission.

Hendrickje and Titus appear before a notary to register a business partnership to trade in "paintings, graphic arts, engravings, and woodcuts, as well as prints and curiosities." All the moveable property

belonging to the painter is assigned to the business. Hendrickje subsequently makes a will appointing Rembrandt sole guardian of their daughter Cornelia and transferring her share of the art business to him. Rembrandt's insolvency account is closed in December.

- *Portrait of Titus*★ (Paris, Musée du Louvre)
- *Self-Portrait* (New York, The Metropolitan Museum of Art)
- *A Man Holding Gloves* and its companion portrait *A Woman with an Ostrich-Feather Fan*★ (Washington, D.C., National Gallery of Art)
- *The Apostle Peter Denying Christ* (Amsterdam, Rijksmuseum)

### 1661

Begins work on *Juno* (Los Angeles, Armand Hammer Collection) for Harmen Becker, who will complain four years later that the painting is still not finished.

- *The Oath of Claudius Civilis* (Stockholm, Nationalmuseum)
- *Portrait of Jacob Trip*★ (London, National Gallery)
- *Portrait of Margaretha de Geer*★ (London, National Gallery)
- *St Matthew and the Angel* (Paris, Musée du Louvre)
- *The Apostle Simon* (Zurich, Kunsthaus)
- *The Apostle Bartholomew* (Malibu, J. P. Getty Museum)

- *The Apostle James* (private collection)
- *Self-Portrait as the Apostle Paul* (Amsterdam, Rijksmuseum)
- *Homer Instructing His Pupils*★ (Stockholm, Nationalmuseum)
- *Two Black Africans* (The Hague, Mauritshuis)

### 1662

At some point in the summer Rembrandt's huge (77 × 121¾ in., cut down from 216½ × 216½ in.) *The Oath of Claudius Civilis* is installed in the Town Hall, but is removed and returned to Rembrandt in September.

In October, hard-pressed for funds, Rembrandt borrows 537 guilders from a moneylender and sells Saskia's grave to a gravedigger.

In November, he ships *Homer Dictating to a Scribe* to Don Antonio Ruffo. The latter returns it on the grounds that it is unfinished. Rembrandt agrees reluctantly to put more work into the painting and sends it back to Ruffo the following year.

- *The Sampling Officials of the Draper's Guild* ("*The Syndics*") (Amsterdam, Rijksmuseum)

### 1663

Hendrickje dies in July, one of Amsterdam's nine thousand inhabitants to be carried off by the plague.

- *Lucretia* (Washington, D.C., National Gallery of Art)

**1665**

Titus goes to Leiden in an attempt to drum up business for his father and declares before a notary there, "My father engraves as well as anyone. . . ." In June, Titus receives an 800-guilder legacy from the husband of his great aunt. In September he is awarded 6,900 guilders from the sale of the Sint-Anthoniebreestraat house (his mother's estate being one of Rembrandt's creditors).

Still an avid collector notwithstanding his financial problems, Rembrandt offers to buy a painting by Hans Holbein the Younger for 1,000 guilders.

- *Self-Portrait* ★ § (London, Kenwood House)
- *The Jewish Bride* ★ (Amsterdam, Rijksmuseum)
- *Family Group* ★ (Braunschweig, Herzog Anton Ulrich-Museum)

**1665–67**

Second Anglo-Dutch War.

**1666**

Rembrandt paints the portrait of the poet Jeremias de Decker (St. Petersburg, The Hermitage), who thanks him with the verses: "And still it pleases me (I will not tell a lie) and takes my breath away / To so myself portrayed on a panel by the Apelles of our day. / And what is more, he did not even ask a fee."

- *Lucretia* (Minneapolis Institute of Arts)

**1667**

Peace treaty with England signed at Breda.

Titus comes of age and gains control of what's left of his mother's legacy (originally 20,000 guilders, now shrunk to 7,000 guilders). On December 2, Cosimo de Medici visits Rembrandt's studio.

- *Portrait of a Man* (Melbourne, National Gallery of Victoria)

**1668**

On February 10, Titus marries his aunt Hiskia's niece, the 26-year-old Magdalena van Loo.

The plague returns to Amsterdam. Titus contracts it and dies on September 4.

**1669**

Titus's daughter Titia is born in March and baptized on the 22nd in Amsterdam's Nieuwezijds Chapel, with Rembrandt acting as godfather.

Rembrandt works on his *Self-Portrait as Zeuxis* (or Democritus) § (Cologne, Wallraf-Richartz-Museum), the London § and The Hague self-portraits, *The Return of the Prodigal Son* § (St. Petersburg, The Hermitage), and *Simeon with the Christ Child in the Temple* § (Stockholm, Nationalmuseum).

In September, the painter Allaert van Everdingen and his son Cornelis visit Rembrandt in his studio and notice the

unfinished *Simeon with the Christ Child in the Temple.*

Rembrandt dies on October 4, survived by the fifteen-year-old Cornelia, his daughter with Hendrickje, and the infant Titia. A notary is summoned to make a list of the painter's belongings (four green lace curtains, several pewter candlesticks, a brass pestle; earthenware dishes, old and new neckties; half a dozen pillowcases, four plain chairs, one old mirror, and three roomfuls of paintings, drawings, rarities, and antiquities, which are declared the property of Titia).

Rembrandt is buried four days later at the Westerkerk ("October 8, 1669, Rembrandt van Rijn, a painter dwelling on the Rozengracht across from the Doolhof [amusement park], coffin with sixteen pallbearers; survived by two children [actually a daughter and a granddaughter]. Fees received: 20 guilders").

Titia's mother Magdalena dies nine days later. Titia herself will survive into adulthood. She will marry an Amsterdam jeweler and die in the second decade of the eighteenth century. Her aunt Cornelia will marry a painter named Cornelis Suythof at the age of sixteen. She and her husband will sail to Batavia soon after, where, there not being much demand for artists, Suythof will supplement his income by taking work as a jail keeper. They would have two sons, both born in the Far East—Hendrick and Rembrandt.

# Bibliography

Alpers, Svetlana. *Rembrandt's Enterprise: The Studio and the Market.* Chicago and London: The University of Chicago Press, 1988.

Bailey, Antony. *Rembrandt's House.* Boston: Houghton Mifflin, 1984.

Benesch, Otto: *The Drawings of Rembrandt: A Critical and Chronological Catalogue.* 6 vols. London: Phaidon, 1954–57.

Blankert, Albert. "Rembrandt, Zeuxis and Ideal Beauty," in *Album Amicorum J. G. van Gelder.* The Hague: Martinus Nijhoff, 1973, pp. 32–39.

Boon, Karel G. *Rembrandt, The Complete Etchings.* London: Alpine Fine Arts Collection, 1987.

Bredius, Abraham. *The Paintings of Rembrandt.* 2 vols. Vienna: Phaidon Press; Oxford: G. Allen, 1942.

————. *Rembrandt: The Complete Edition of His Paintings.* Revised by H. Gerson. London: Phaidon, 1969.

Brown, Christopher, Jan Kelch, and Pieter van Thiel. *Rembrandt: The Master and His Workshop.* New Haven, CT, and London: Yale University Press in association with National Gallery Publications, 1991.

Bruyn, J., B. Haak, S. H. Levie, P. J. J. van Thiel, and E. van de Wetering. *A Corpus of Rembrandt Paintings by the Rembrandt Research Project.* The Hague, Boston, and London: M. Nijhoff, vol. 1 (1625–31), 1982; vol. 2 (1631–34), 1986; Dordrecht: M. Nijhoff, vol. 3 (1635–42), 1989; Dordrecht: Springer, vol. 4 (Self-Portraits), 2005.

Chapman, H. Perry. *Rembrandt's Self-Portraits, A Study in Seventeenth-Century Identity.* Princeton, NJ: Princeton University Press, 1990.

Chong, Alan, and Michael Zell, eds. *Rethinking Rembrandt.* Zwolle: Wanders, 2002.

Clarke, Kenneth. *Rembrandt and the Italian Renaissance.* London: J. Murray, 1966.

Foucart, Jacques. *Les Peintures de Rembrandt au Louvre.* Paris: Éditions de la Réunion des musées nationaux, 1982.

Fromentin, Eugène. *Les Maîtres d'autrefois, Belgique-Hollande.* Paris: Garnier, 1972.

Genet, Jean. *Rembrandt* ("Le Secret de Rembrandt" suivi de "Ce qui est resté d'un Rembrandt déchiré en petits carrés bien réguliers, et foutu aux chiottes"). Paris: Gallimard, 1995.

Gerson, Horst. *Rembrandt Paintings.* New York: Reynal & Co., 1968.

———. *Rembrandt, "La Ronde de Nuit."* Fribourg: Office du Livre, 1973.

Gombrich, E. H. "Rembrandt Now," *The New York Review of Books,* March 12, 1970, pp. 6–15.

Haak, Bob. *Rembrandt: His Life, His Work, His Time.* New York: Abrams, 1969.

Herbert, Zbigniew. *Still Life with Bridle.* Trans. John Carpenter and Bogdana Carpenter. New York: Vintage, 1991.

*The Impact of a Genius: Rembrandt, His Pupils and Followers in the Seventeenth Century: Paintings from Museums and Private Collections.* Introductions by Albert Blankert, B. Bross, E. van de Wetering et al. Amsterdam: K. & V. Waterman, 1983. An exhibition catalogue.

Lecaldino, Paolo, and Jacques Foucart. *Tout l'oeuvre peint de Rembrandt.* Trans. Alain Veinstein. Paris: Flammarion, 1971.

*Regards sur l'art hollandais du XVIIe siècle: Frits Lugt et les frères Duthuit, collectionneurs.* Paris: Adam Biro / Fondation Custodia, 2004.

Roger-Marx, Claude. *Rembrandt.* Paris: Tisné, 1960.

Rosenberg, Jakob. *Rembrandt.* 2 vols. Cambridge, MA: Harvard University Press, 1948.

Schama, Simon. "Rembrandt and Women," *Bulletin of the American Academy of Arts and Sciences* 38 (1985).

———. *Rembrandt's Eyes.* London: Penguin, 2000.

Schupbach, William. *The Paradox of Rembrandt's "Anatomy of Dr. Tulp."* London: Wellcome Institute for the History of Medicine, 1982.

Schwartz, Gary. *Rembrandt: His Life, His Paintings.* New York: Viking, 1985; London: Penguin, 1991.

——. *The Complete Etchings of Rembrandt Reproduced in Original Size.* New York: Dover Publications, 1994.

Slive, Seymour. *Drawings by Rembrandt.* New York: Dover Publications, 1965.

Strauss, Walter L., and Marion van der Meulen, eds. *The Rembrandt Documents.* New York: Abaris Books, 1979.

Tümpel, Christian. *Rembrandt.* New York: Abrams, 1996.

Van de Wetering, Ernst. *Rembrandt: The Painter at Work.* Amsterdam: Amsterdam University Press, 1997.

White, Christopher. *Rembrandt.* New York: Norton, 1984.

——, ed. *Rembrandt by Himself.* London: National Gallery Publications, 1999.

White, Christopher, and Karel G. Boon. *Rembrandt's Etchings. An Illustrated Critical Catalogue.* 2 vols. Amsterdam: A. L. van Gendt, 1969.

Zell, Michael. *Reframing Rembrandt.* Berkeley: University of California Press, 2002.

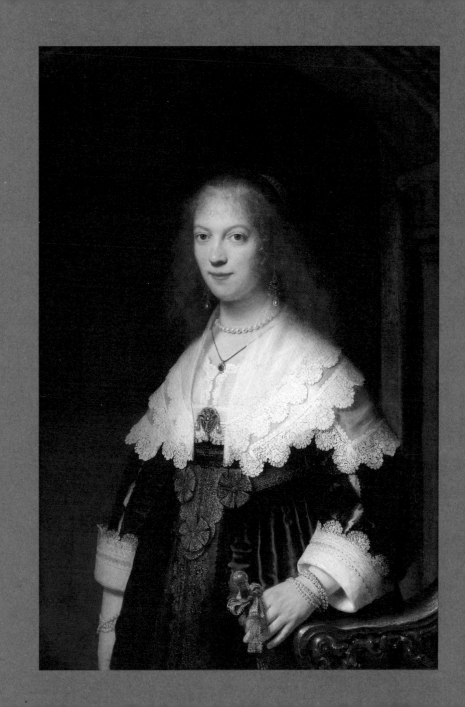